IMAGES
of America

BEVERLY HILLS
COUNTRY CLUB

To Lance 1969
Jim Fairbanks
Astle

Paul Astle's parents
lived for (in Park Hills)
for 38 years.
March 1986
Jim Astles
died & we
sold house

Bought at Berringer Museum
in Devou Park / near our
house on Cleveland Ave.
Covington, Ky.
in 2008

Mary Astles - '46

Devou has 18 hole golf course
Band Shelter
Fire & Police Station
Museum
Lot of expensive homes in
Park Hills & Kenton Hills
Early 1900's gave to
Covington.

Papaw McGee used to go to
this Park when he was
a young kid. Mr. Devou
gave it to Covington
1924
Ky. as a gift.

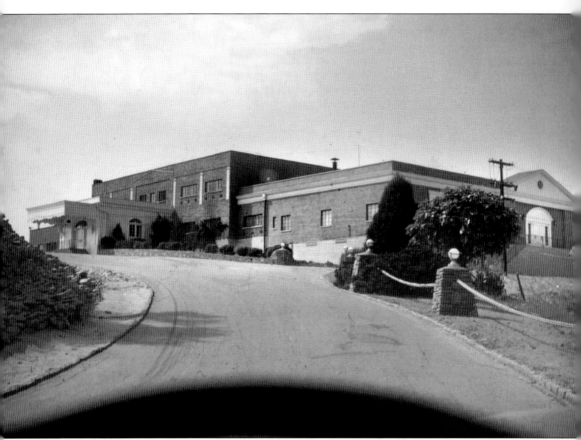

High atop a hill in Southgate, Kentucky, was the Old Kaintuck Castle Club. In 1935, Newport businessman Peter Schmidt bought the club and refurbished it, naming it after his granddaughter. The lavish new Beverly Hills Club featured a restaurant, a circular bar, live entertainment, and a casino. After a fire in 1937, Schmidt rebuilt the club and named it the Beverly Hills Country Club. After Schmidt sold out, the Cleveland Syndicate set it on course to become one of the premiere showplaces of the United States. The large block-shaped wing to the right was added after 1937 to hold a larger casino. (Courtesy of Earl W. Clark.)

ON THE COVER: Montana native Constance Towers had aspirations to sing opera, but her career went in other directions. She sings on the Beverly Hills stage and cues the orchestra for an impromptu number. At this time, she was trying to break into films and starred in *Bring Your Smile Along* in 1955. Recent audiences might remember her for an appearance on *Star Trek: Deep Space Nine* in 1993 and as the villainess Helena Cassadine on *General Hospital*. She continues to act today. (Courtesy of Earl W. Clark.)

IMAGES of America
BEVERLY HILLS COUNTRY CLUB

Earl W. Clark and Allen J. Singer

ARCADIA
PUBLISHING

Copyright © 2010 by Earl W. Clark and Allen J. Singer
ISBN 978-0-7385-6619-1
Published by Arcadia Publishing
Charleston SC, Chicago IL, Portsmouth NH, San Francisco CA

Printed in the United States of America

Library of Congress Control Number: 2009925365

For all general information contact Arcadia Publishing at:
Telephone 843-853-2070
Fax 843-853-0044
E-mail sales@arcadiapublishing.com
For customer service and orders:
Toll-Free 1-888-313-2665

Visit us on the Internet at www.arcadiapublishing.com

*This book is dedicated to the memory of
Gardner Benedict, orchestra leader at the Beverly Hills
Country Club during the club's golden age of the 1950s.*

*This book is further dedicated to the memory of the musicians
who perished the night of the fire in 1977. May their contributions
be always remembered: Robert Roden, Glenn Seaman,
Paul Smith, John Twaddel, Everett Neil, Richard Pokky, and
John Davidson's musical director, Douglas George Herro.*

Contents

Acknowledgments		6
Introduction		7
1.	We're in the Band	9
2.	A Chorus Line	17
3.	The Openers	29
4.	Time for Rehearsal	41
5.	Gather 'Round the Piano	53
6.	The Couches and Photograph Wall	63
7.	Paparazzi Shots	79
8.	May I Take Your Picture?	95
9.	On Stage at Beverly Hills	121

Acknowledgments

Thanks go to those who shared information for a few images that required clarification: Carmel Quinn; Dick Contino; Shecky Greene; Fred Favorite of the Bob Devoye Trio; Sam Younghans, for identifying the Vagabonds; Gloria Burke, representing the Modernaires; Denny Hammerton of www.hellodere.com for assisting with Marty Allen and Mitch De Wood; Kathy Kroll of www.kathykroll.com regarding Donn Arden, longtime producer of Beverly Hills shows as well as shows in Las Vegas and Paris; Lee Elliot (and Moonbeam); John Kiesewetter; and Bill Myers for copyediting. All images appear courtesy of author Earl W. Clark.

INTRODUCTION

Ten minutes south of Cincinnati, the most luxurious showplace in the Midwest sat atop a grassy hill off U.S. Route 27 in Southgate, Kentucky. Every night of the week in the 1950s, sellout crowds flocked to Beverly Hills Country Club to watch the world's greatest entertainers perform. No secret to café society, this nightclub attracted local clientele and high rollers flying in from New York and Chicago.

From the 1930s to the early 1960s, Northern Kentucky was replete with nightclubs and gambling. Local businessman Pete Schmidt opened the Beverly Hills Club in Southgate in 1935 with a casino and live entertainment. An organized gaming group, the Cleveland Syndicate, wanted it. When Schmidt refused to sell, the club burned down. Arson was suspected but never proven. After he rebuilt it, Beverly Hills Country Club reopened in 1937, and Schmidt finally sold out.

The Cleveland Four (Moe Dalitz, Morris Kleinman, Louis Rothkopf, and Sam Tucker) ran Beverly Hills like the Desert Inn they operated in Las Vegas. They put in a rotating chorus line, and their connections brought in headliners from the major entertainment circuits. With affordable dinners, the draw of big stars, and the lure of the casino, customers came pouring in. After 20 successful years, crackdowns and grand jury indictments closed all gambling in 1961.

Beverly Hills stayed open without gambling, and business consequently plummeted. New budget cutbacks cancelled all shows and shrank the orchestra by half. The employees lost their jobs. The show people moved on.

On New Year's Eve 1961, Beverly Hills closed. Eight years later, local businessman Dick Schilling bought it and renovated it. Before it could open, it was completely gutted by fire. Schilling rebuilt it and opened it in 1971, without a casino.

The new Beverly Hills Supper Club was grand and plush. As before, there was dinner and a show, but the club also catered to proms, weddings, birthday parties, graduations, and conventions. Then, on May 28, 1977, Beverly Hills came to a tragic end when the club caught fire. A capacity crowd had come to see headliner John Davidson. One hundred, sixty-five patrons, musicians, and employees lost their lives in one of the nation's worst nightclub disasters. The site stands vacant now except for a historical marker commemorating the deadly event.

Modern generations equate Beverly Hills with tragedy, and understandably so. However, its legacy should be that of happiness. Decades before the fire, it was an unforgettable place to visit, and equal to the best clubs in Las Vegas, Miami, New York, Chicago, and Los Angeles.

Two entertainment-packed shows went on every night at Beverly Hills, three on Saturdays, seven days a week. A four-course dinner costing $2.95 was served with high style in the Trianon Room before and after the show. At 8:00 p.m., the lights dimmed and the curtains swept open.

The audience applauded as a dazzling production number filled the stage, opening the show with a line of dancers high-kicking to music provided by the Gardner Benedict Orchestra. Afterwards, the first act, possibly a juggler or tap dancer, took the stage. The second act could be a comedian or a singer. A ballet number followed. The featured headliner then came on for 45 minutes. A "flag waver" finale closed the show.

After giving a standing ovation, audience members then played bingo or followed the headliner into the casino. While the orchestra took a break, some of the audience danced on stage to the

music of the Jimmy Wilbur Trio. The second show started at 11:30 p.m., and if it was Saturday, the third show began at 1:00 a.m. Two weeks later, a different headliner would appear, along with an entirely new show.

Thanks to gambling, Beverly Hills could afford to bring in high-class entertainment like movie stars, opera singers, Broadway actors, and the day's top recording artists. Also crossing the stage were lesser-known acts: comedians, jugglers, vocal quartets, dance teams, animal acts, balancing acts, and even roller skaters. Some big names were not booked. Though Frank Sinatra did not perform at Beverly Hills, he did visit. After he caught a show, Sinatra reportedly spent $30,000 at the gaming tables.

Beverly Hills catered to the over-30 crowd; the musical acts were chosen based on what they preferred. Young adult record store patrons bought sophisticated music—full of romance and lush orchestrations recorded by the day's top crooners. These were the sorts of performers who tended to headline at Beverly Hills. This music held little appeal to the early-1950s teenage bobby-soxers, who coincidentally were too young to gamble in Beverly's casino. But rock-and-roll numbers were hitting the charts in 1955. By 1958, most record buyers were teenagers. The popular music scene was changing.

Despite this, Beverly Hills never featured any rock and roll. Cleveland booking agents Frank and Rocky Sennes handled the talent and did not consider the tastes of a potential young crowd.

Those who patronized Beverly Hills found it an unforgettable place to visit. The employees enjoyed it immensely. One waiter reminisced, "It was a fabulous place to work."

In 1951, saxophonist and author Earl W. Clark joined the Gardner Benedict Orchestra. Starstruck by all the talent, he began taking his Argus C3 35-millimeter camera to work. For the next decade he photographed everyone from the top stars down to the novelty acts. His subjects frequently posed in the backstage dressing rooms. Other times, surprise candid shots were taken while the entertainers chatted or relaxed, often while holding a cigarette.

Clark took the pictures during intermissions, sometimes moments before the start of the show. Many were taken beside one of the three couches backstage underneath the walls of photographs, like the headshots that graced the walls in Hollywood's Ciro's. Clark even snapped a few from the orchestra during a performance when not busy reading the score.

Thirteen years worth of wonder were captured during those fabulous nights. The images were made into slides so Clark could project them onto a screen. Over the coming decades, some slides deteriorated, resulting in a reddish hue. Frequent handling caused scratches and spotting in some. Flaws or no flaws, the images are imbued with a distinct 1950s flavor and reveal a unique view of life behind the stage at one of the nation's leading showplaces.

Clark played with many fine orchestra musicians at Beverly Hills over the years and has never forgotten them. Within these pages are: Frank Bowsher, sax; Carl Grasham, drums; Wally Hahn, trumpet/violin; Andy Jacob, violin; Jim Langenbrunner, tenor sax; Harold Marco, drums; Charlie Medert, trumpet; Bill Mavity, trumpet; Al Miller, tenor sax; Fritz Mueller, trumpet; Bill Rank, trombone; Bud Ruskin, bass; Glenn "Hap" Seaman, tenor/baritone sax; Wilbur "Shooky" Shook, drums; George Thomas, sax; Ted Tillman, drums; Marty Weitzel, sax; Dick Westrich, trumpet; Bob Wheeler, alto sax; Pierson DeJager, trumpet; and the Jimmy Wilbur Trio, including Dick Garrett, Bill Kleine, and Frank Gorman.

Thanks to the Internet, modern readers can experience the entertainers presented in these pages. Most acts in this book can be seen or heard on YouTube. Readers are urged to visit the Web site and experience entertainment that was, for many years, a mainstay of the nightclub scene and has been largely overlooked by recent generations.

The era has ended, but it has left behind a great legacy. In Clark's own words, he reflects, "It was a wonderful time and a long run for us, here in Northern Kentucky. A time which will never return. Gambling is now legal in some places, but not bearing the glamour of the Beverly surroundings. The clientele has changed from the once well-dressed and well-groomed. The songs have ended, too, but the memories linger on." And so they shall.

One

WE'RE IN THE BAND

In 1951, pianist Gardner Benedict came to Beverly Hills for a third engagement and invited local saxophonist Earl Clark to join. The 10-piece orchestra (seen here) provided all the music at Beverly Hills, although up to 20 pieces were sometimes needed. Pictured from left to right are (first row) Gardner Benedict, Fritz Mueller, Bill Mavity, Dick Benedict, and Glenn Seaman; (second row) Bud Ruskin, Wally Hahn, Ted Tillman, Andy Jacob, and Earl Clark.

Earl Clark picked up the saxophone at age 13. By the next year, he was playing seven nights a week all over the Cincinnati/Northern Kentucky area and abroad. At Beverly Hills, he backed hundreds of the world's greatest entertainers. When the club closed in 1962, Clark laid down his saxophone and took a full-time job, playing part time when he could.

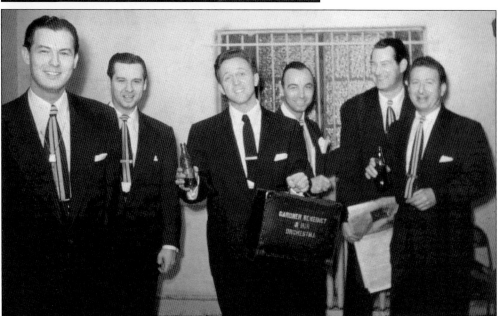

It is the night before vacation in the musicians' dressing room. The Gardner Benedict Orchestra is ready to take some much-needed time off while the Ted Lewis Orchestra stands in. Holding a box of dance music, Gardner Benedict (center) toasts to two weeks of happy relaxation. The bottle of Coca-Cola he holds came from the backstage vending machine. Pictured from left to right are Earl Clark, Bill Mavity, Gardner Benedict, Andy Jacob, Fritz Mueller, and Harold Marco.

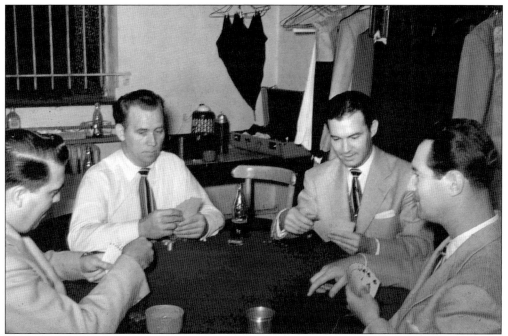

Between shows, the musicians often passed the time by drinking Coca-Cola and playing Hearts in their dressing room. The casino down the hall provided the cards. When they tired of this, the musicians drove to the drugstore to buy milk shakes. Dressed in grey jackets, from left to right, are Hap Seaman, Wally Hahn, Earl Clark, and Fritz Mueller.

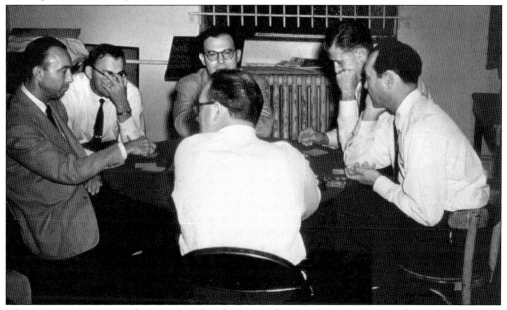

The musicians grow restless as they finish up another card game close to show time. Famous nightclubs like Beverly Hills maintained tight security. In addition to a high-tech security system on the grounds surrounding the club, steel bars covered all windows, even in the musicians' dressing room. Clockwise, starting at far left, are Andy Jacob, Dick Westrich, Earl Clark, Bill Rank, George Thomas, and Ted Tillman.

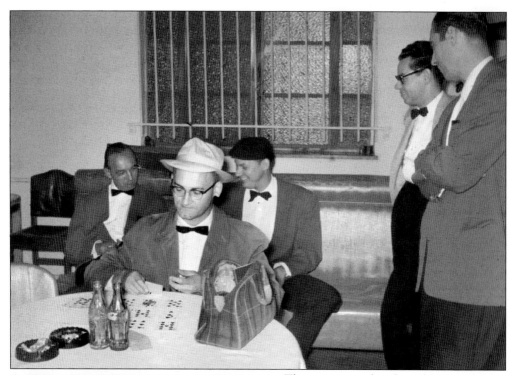

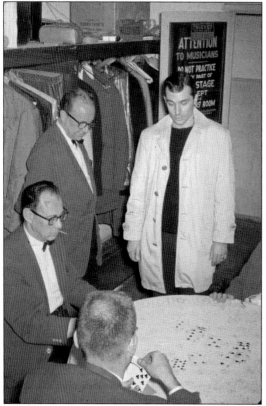

The musicians played until 2:00 am and even later on Saturdays. If the crowd was small, the band expected to leave early. Bedecked in their red jackets, the musicians joke in their dressing room while waiting to go onstage. Dick Westrich (seated) is dressed and ready. Note the full ashtrays and empty Coca-Cola bottles in front of him. From left to right are Andy Jacob and Carl Grasham (seated behind Westrich), along with visiting Cincinnati Symphony Orchestra trombonist Tony Chipburn and Al Miller (standing).

The activities in the musicians' dressing room frequently attracted attention. That night's production singer, standing near the door, has come to check things out. Clockwise from forefront are Dick Westrich, Bud Ruskin, and Shooky Shook. The sign on the door advises musicians against practicing backstage because audience members could hear them. A smaller sign warns "Thieves and Fake Agents Keep Out."

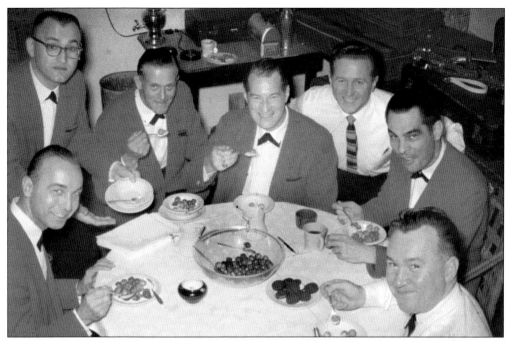

At the end of a successful two-week engagement, the headlining act traditionally gave the house musicians a thank-you gift, usually jewelry or liquor. Jimmy Durante had the kitchen prepare them "the ultimate dessert." The Gardner Benedict Orchestra is enjoying strawberries and cream—an item not on the menu. From left to right are Andy Jacob, Dick Westrich, Bill Rank, Fritz Mueller, Gardner Benedict, Al Miller, and Bob Wheeler. A plate of Oreo cookies sits in front of Wheeler.

The first show ended at 9:30 p.m., the second began at 11:00 p.m. During intermission, the Jimmy Wilbur Trio played dance music for audience members. Pictured here is the trio posing with a dancer costumed for an Indian-themed ballet number. From left to right are Frank Gorman, Dick Garrett, the unidentified dancer, and Jimmy Wilbur. Another unidentified dancer steps off to the right.

The Jimmy Wilbur Trio often invited guest singers. The woman posing with them is the stooge in a comedy-supporting act and appears on page 74. Since she was a singer, the trio asked her to join them. Here they pause between songs while audience members behind them smile and applaud. From left to right are Dick Garrett, Bill Kleine, the unidentified singer, and Jimmy Wilbur.

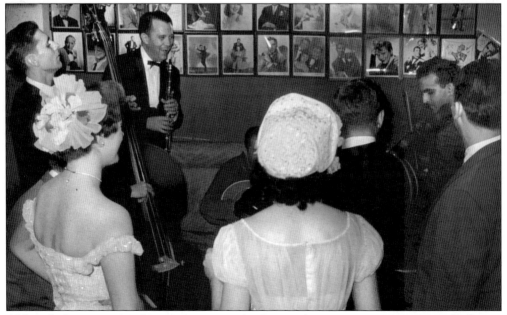

Although the signs warned against practicing backstage, this spontaneous jam session broke out on the couch by the wings. At left, the Jimmy Wilbur Trio jams with musicians from Carmen Miranda's band to the right. Two chorus girls and Wally Hahn (far right) watch them with unbridled delight.

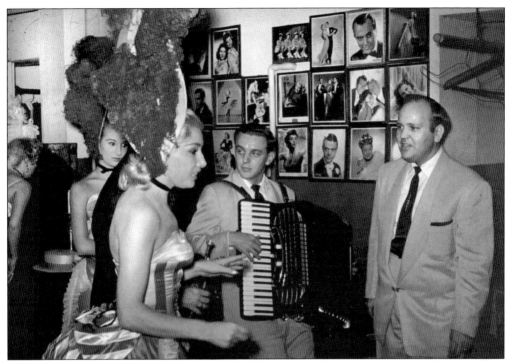

A dancer wearing a frilly blue and white costume chats with Bob McSpadden (far right) of the Jimmy Wilbur Trio. Bill Kleine accompanies them with appropriate conversation music on the accordion. At far left, another dancer examines her makeup in the mirror, ignoring the scene unfolding behind her.

When a two-week run closed, Beverly Hills hosted a formal dinner for the staff. At 2:00 a.m., musicians and employees enjoyed a four-course party meal. To drink are bottles of Canada Dry ginger ale, Hudephol beer, and wine. In the foreground are lounge entertainer Larry Vincent (left) and Gardner Benedict. A vocal quartet is positioned toward the back. Dancers are in the top right. The Jimmy Wilbur Trio sits at the right-hand table.

Headliner Billy Williams (second from left) quips his catch-phrase, "Oh, yeah!" as members of the Billy Williams Quartet pose with musicians by the stage door. Bill Mavity (third from left) and Earl Clark (far right) enjoyed the company of the featured artists. The quartet recently had a hit record with their 1957 R&B version of "I'm Gonna Sit Right Down and Write Myself a Letter."

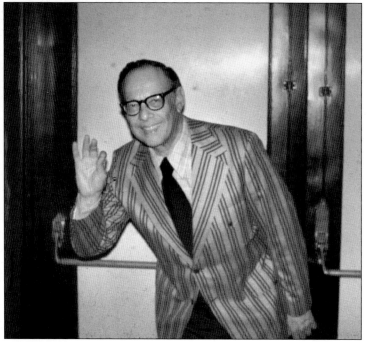

Unfamiliar to many modern readers is a then often-imitated pose associated with actor and television personality Groucho Marx. As Bud Ruskin opens the exit door, he strikes Groucho's famous pose: bent at the waist and miming holding a cigar. He is on a break for some fresh air after the first rehearsal.

Two

A Chorus Line

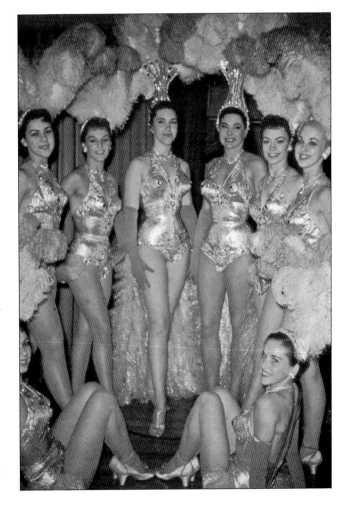

Unique to Beverly Hills was the variety of dancers that opened each show. The nightclub hosted famous dance companies from around the world. Las Vegas choreographer Donn Arden brought the showgirl image from the Lido in Paris: tiny, sequined dresses, feather accoutrements, and tall headpieces. In moments, the curtains will open, and the Donn Arden Dancers from Las Vegas's Desert Inn will begin their routine. This was one reason why Beverly Hills was known as the "Las Vegas of the East."

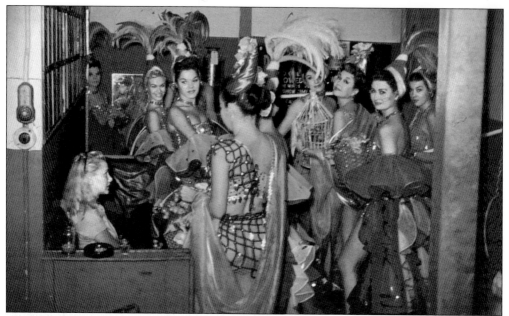

Dancers changed every two weeks. In town are the dancers from the New York City's Latin Quarter nightclub, run by Lou Walters, the father of television's Barbara Walters. Many superstar headliners appeared there and at Beverly Hills. The dancers, wearing green, pink, and purple outfits, wait for their cue in the wings beside their dressing room.

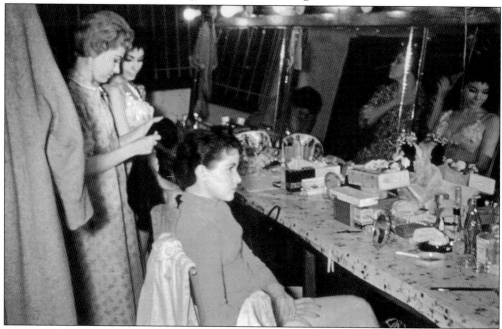

It was a big, happy family at Beverly Hills. The dancers did not mind when Clark dropped into their dressing room to visit. This rare scene shows the Dorothy Dorben Dancers from the Chez Paree in Chicago primping for their show. Like New York's Latin Quarter, the Chez Paree featured top entertainers. From left to right are Jean, Terri, and Mari Jo at the table. Two unnamed girls can be seen in the mirror toward the back.

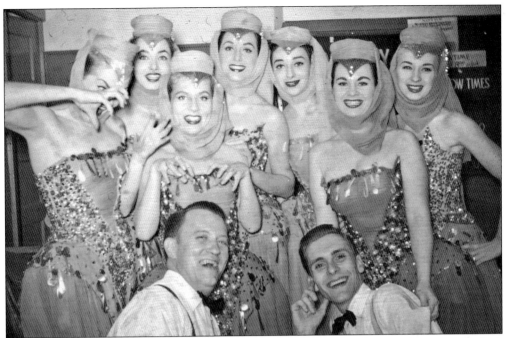

With intermission over, some Dorothy Dorben Dancers are in full makeup and costume for their Arabian nights–themed show. Having fun with them are Jimmy Wilbur (left) and Dick Garrett, who are on break until the next intermission.

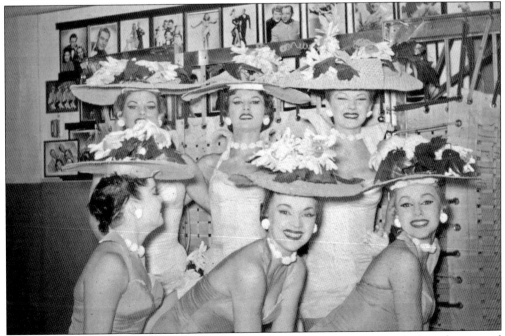

On another night, the Dorothy Dorben Dancers donned bright yellow and white dresses and sunflower hats for a springtime-themed production number. Six of them posed for the camera in front of a trampoline, which an acrobatic supporting act will use later. At the end of their two-week run, this dance team will either head home to Chicago, or on to Miami or New York.

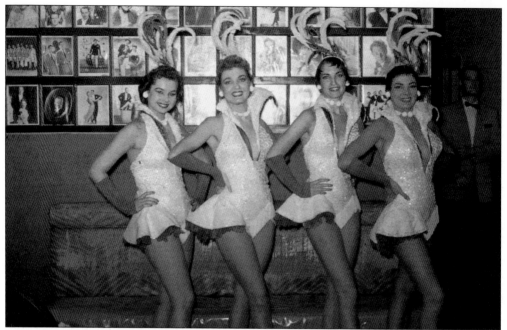

Often the local dancers organized their own theme shows. This week, four showgirls proudly display their low-cut costumes and high-plumed head wear. Fritz Mueller waits politely in the hall at far right.

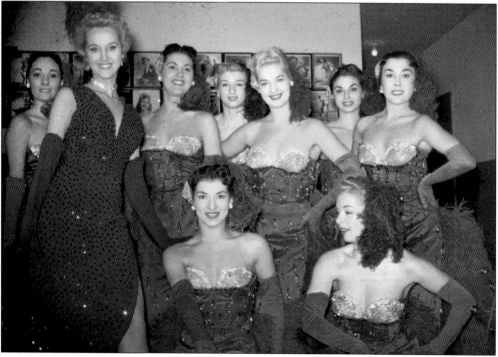

The dancers in dazzling blue dresses have gathered for Clark's camera. They will not go on for nearly 15 minutes. Dance teams changed often to give audiences something new every time they came to Beverly Hills, guaranteeing repeat business. This particular line came from Las Vegas.

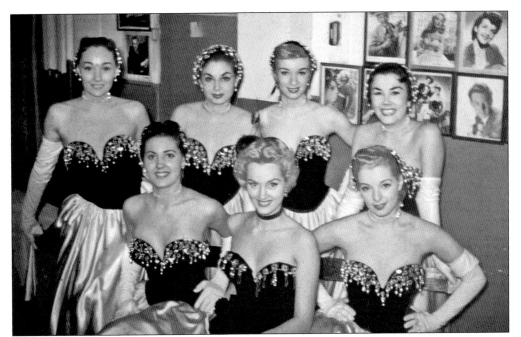

One can only imagine the show this group performed, hailing from Las Vegas. The dresses on these dancers boast satin-colored skirts and midriffs with shiny sequins, complementing the elbow-length white gloves. These dancers add needed glamour to the plain backstage walls.

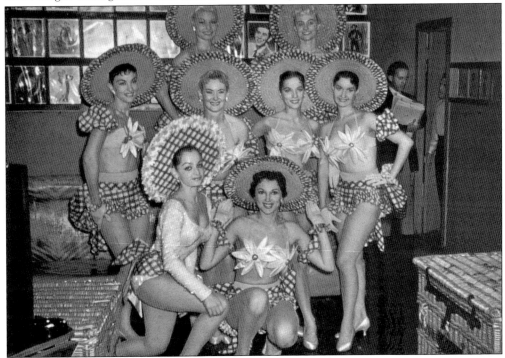

A springtime picnic-themed show featured dancers wearing gingham dresses and daisies on their bosoms. In the hallway behind them, Gardner Benedict (left) reviews the music cues with that night's comedian standing in the doorway of his dressing room.

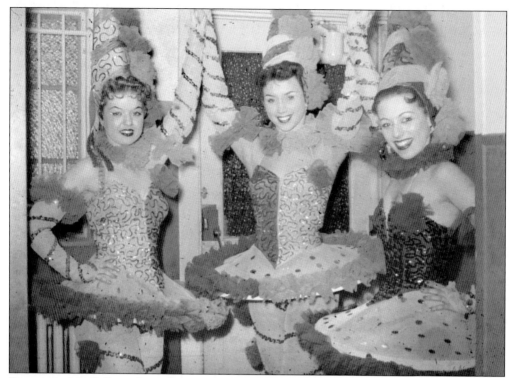

Dancers in Mardi Gras–themed costumes pose in front of the stage door. The actors entered the club through this door. Off-camera at left is the telephone booth, and unseen to their right is the Coke machine.

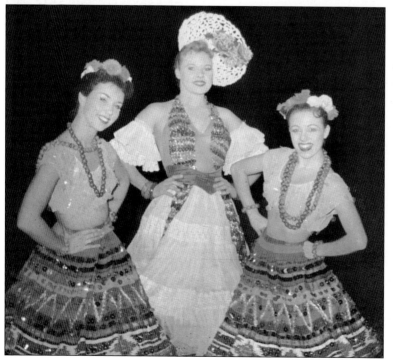

Dressed for their second number of the evening, the same three dancers pose outside on a warm summer night underneath a bright Kentucky moon.

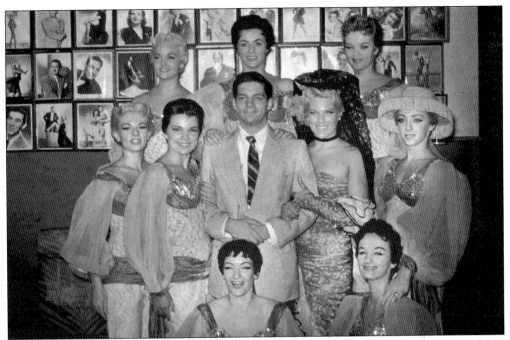

The ladies danced in choreographed numbers as a male performer sang lead vocals. Television actor Bill Hayes was a production singer at Beverly Hills. He poses here with the Lindsay Dancers before their first show. The tallest of the girls were commonly called showgirls or walkers, and they posed and walked the stage. The shorter girls, called ponies, danced and high-kicked.

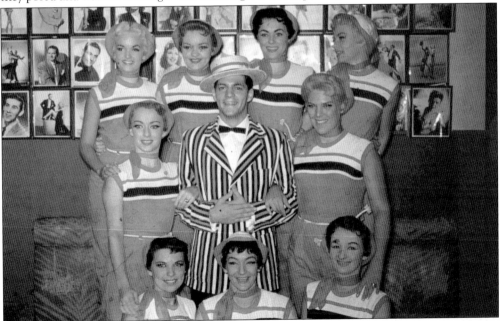

The Lindsey Dancers surround Bill Hayes before the final number, which had a sports theme. Hayes cut records, sung on Sid Caesar's *Your Show of Shows*, and appeared on Broadway's *Me and Juliet* in 1953. Later he played lounge singer Doug Williams on *Days of Our Lives* from the 1970s through the 2000s.

The themes changed frequently and sometimes reflected the traditions of European culture. This week's program depicted the Bal des Quat'z'Arts, an annual costume ball in France that celebrated the four Parisian arts.

The curtain that opens to the wings is to the right of these four showgirls. Before joining the band, Clark pauses to photograph the dancers wearing shiny burgundy dresses and feathers on their heads. Behind them, a sign warns those backstage not to enter the wings during the show.

With castanets in her hands, Big Mary struck a typical showgirl pose as she rehearses 30 minutes before her Spanish-themed production. Behind her, Mary Fassett, an 18-year-old local soprano from Hamilton, speaks in hushed tones with the stage manager.

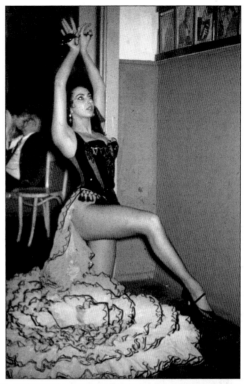

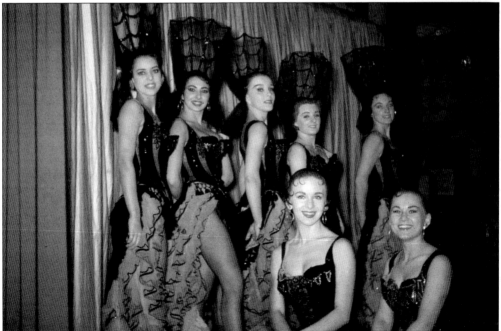

Big Mary stands second from left with the rest of the dancers in that night's show. Beverly Hills regular Marlene Powers kneels at left. Among those pictured are, from left to right, (standing) Peggi, Mary, Joan, and two unidentified; (kneeling) Marlene Powers and guest singer Mary Fassett from Hamilton.

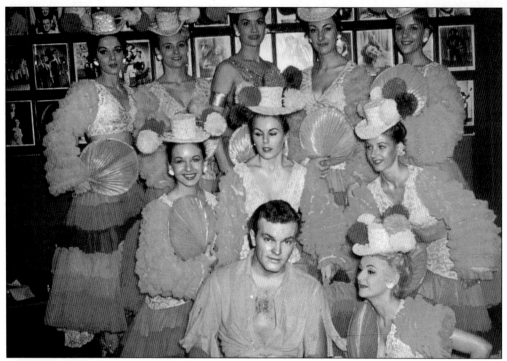

The bright yellow and orange dresses augmented with fans, hats, and puffy sleeves were inspired by the Latin American dance styles of Cuba. Some of these dancers came from the Palmer House in Chicago and the Ice Show at Chicago's Conrad Hilton Hotel. Marlene Powers is on the far left in the second row. The production singer at the bottom offers a distracted smile.

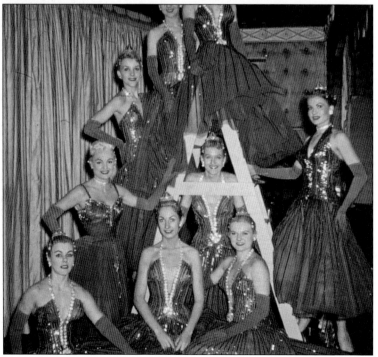

Minutes before the curtain was to sweep open, these dancers in emerald green evening gowns pose on a ladder used in their show. The chorus lineup always included at least 10 to 12 dancers.

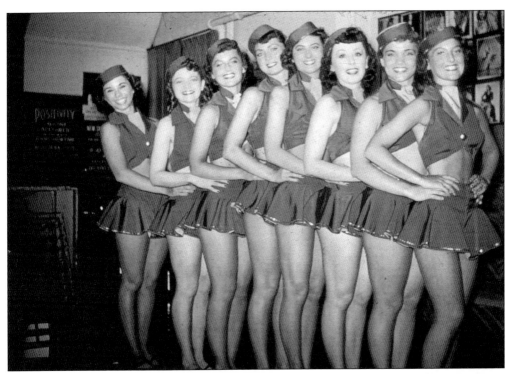

The Lucky Girls dancers have lined up wearing brown pillbox hats and skimpy crop tops in a style reminiscent of the fashions of World War II. However, women in wartime never wore skirts as short as these. Patricia McCrea, far left, is the only identified dancer.

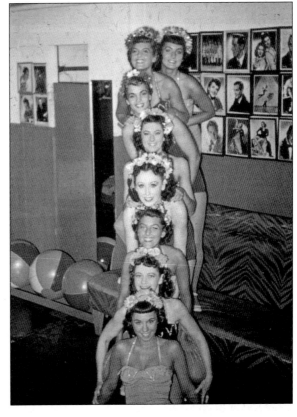

The Lucky Girls have changed into swimsuits for a beach-themed show for the evening's final number. The beach balls at left will be tossed around during their performance. "Mom and Pop," a European couple, managed this acrobatic dance group and toured the country's leading nightclubs.

Beverly Hills dancers performed for a number of months and then headed off for other jobs. Dorie Svening, shown in a white and pink hoop dress, was a regular who had left some years earlier to tour nationwide. By this time, she has returned and became a prominent member of a dance team.

Even backstage at a nightclub, the house performers still celebrated Christmas. Every year, the staff decorated a tree to make the place feel like home. The name of this chorus girl has been lost, but her smile exudes a feeling of warmth that only the magic of Christmas can bring.

Three
THE OPENERS

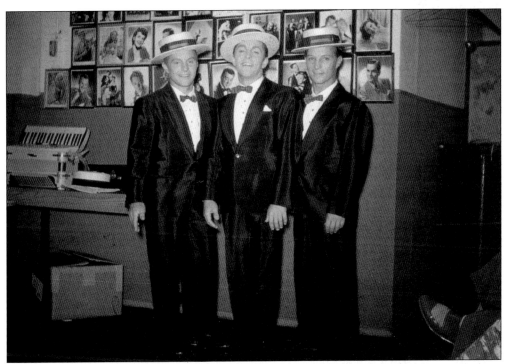

Supporting acts warmed up the audience for the main attraction. Some were so versatile that they could almost do an entire show themselves. Meet the Charlivels, a French acrobatic act consisting of Valentino Rivel, Juanito Rivel, and Charlie Rivel Jr. They danced; sang three-part harmony; played the clarinet, saxophone, vibraphone, and guitar; and performed backflips, handstands, and tumbled all over the stage. Acts like the Charlivels were once a staple of the nightclub scene.

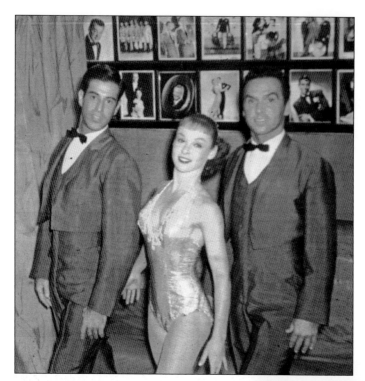

After the 10-minute opening number, the first supporting act took the stage. The critically acclaimed Bob Devoye Trio was considered one of the best dance teams of the mid-20th century. Their show starred, from left to right, Fred Favorite, Sandi Bonner, and Bob Devoye, who danced with lifts, turns, and spins employing characteristics of ballet, modern, and jazz. Sandi Bonner left the group in 1959. The trio went through several female partners, and the group ended in the 1960s when they opened a dance school.

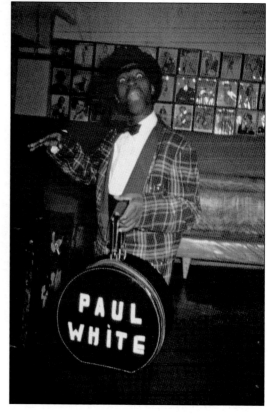

In the 1940s, Ted Lewis sang "Me and My Shadow" and danced while carrying a cane and wearing a top hat. Behind him, another man followed him, mimicking his every move. This man was his shadow, tap dancer Paul White, pictured here on a solo nightclub tour. White has donned the top hat he normally carries in the round box that bears his name.

The second act went on after the opener and featured a singer, a comedian, or a song-and-dance routine. Lesser-known artists usually appeared here, like this performer wearing a pistol and cowboy hat. He was likely a comedian, but similar to many supporting acts, his name has been lost to time.

Oklahoma! was Broadway's 1943 smash musical. The 1955 film inspired nightclub acts, including this trio (below). Western-themed shows made their way to Beverly Hills along with ballroom dancing and acrobatic acts. Note the sign behind them advertising that nobody is allowed in the wings and the warning about the curtains.

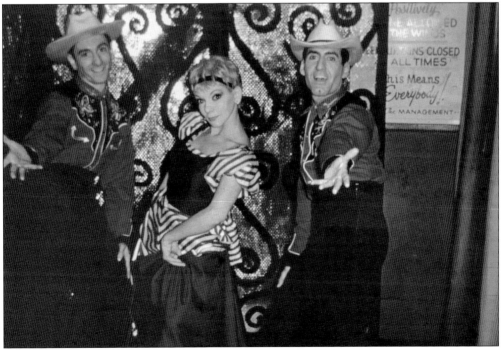

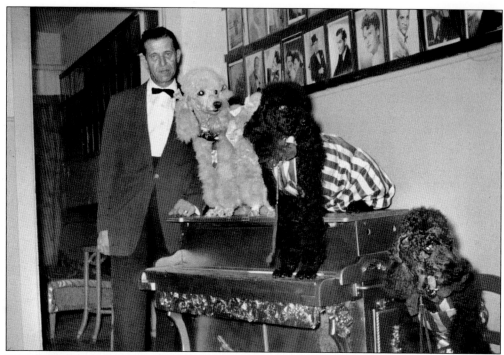

Beverly Hills crowds loved the trained-animal routines. Bill Rank, a trombonist in the house band, strikes a pose with the Joe Navelli act where trained dogs played the piano. Ignoring him, the dogs instead peer down the hall, perhaps smelling food being cooked in the dining room.

Possibly billed as "Poodle Sisters with Their Accompanist," the dogs use this specially designed miniature piano. One of the sisters demonstrates her technique here. Poodles and chimpanzees appeared frequently on stage. The audience roared whenever one had an accident on stage. The trainer had to halt the show for a minute as he cleaned up.

Trained chimpanzees were a staple on the old vaudeville stage and in the 1950s at Beverly Hills as well. This is one half of the Tippy and Cobina act, held by the trainer, Señor Rivera. In their act, Tippy and Cobina made telephone calls and played an electric organ, always mugging for a camera.

Below, these two men in tuxedos and the woman wearing a red evening gown were part of a three-person acrobatic act who used the trampoline behind them. The trio performed jumps, flips, and spins in a stage act that has virtually disappeared from the nightclub scene.

World-class juggler Francis Brunn kept in top form by rehearsing every chance he got. Born in Germany, Brunn started juggling in 1939 and joined a traveling European show. He immigrated to New York after World War II and joined the Ringling Brothers circus. He appeared on television and stages nationally, making it to Beverly Hills around 1955.

In the dressing room of Ford and Reynolds, the musical/comedy team has been caught in a candid shot before their show. Ford, standing to the right, told jokes while Reynolds played saxophone accompaniment. Ford and Reynolds were a lesser-known nightclub act but made it onto television shows, including *Toast of the Town*.

Mexico native Rudy Cardenas ranked next to Francis Brunn as one of the top jugglers in the world. Like Francis Brunn, he rehearsed his act whenever he had a spare second. He first appeared in Miami in 1948, which led to a five-year contract with Paramount Pictures. Later he became a Las Vegas regular and was twice voted best novelty act. He would receive the International Jugglers' Association Historical Achievement Award in 1995.

A nightclub act that never made it big was Haller and Hayden. This knockabout comedy duo played mostly regional clubs. Benny Hayden and Joe Haller opted to strike a pose from their "arrow through the head" routine for Clark's camera.

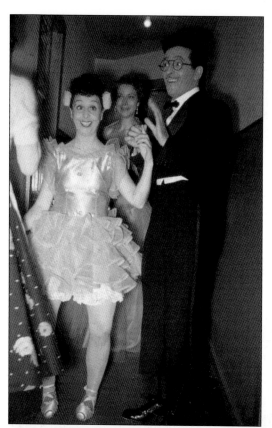

Seconds before they take the stage, the comedy duo Elsa and Waldo get into character for their comic ballet. Acts like this were typical of the Spanish vaudeville circuit and played in European theaters and opera houses. Elsa and Waldo appeared at American nightclubs and on 1950s television shows, including *Toast of the Town*.

James Edmondson was an old-time vaudevillian and stand-up comic. On stage, Professor Backwards accepted challenges from the audience and wrote the words upside down and backwards on his chalkboard. He could spell and pronounce words backwards and read inverted writing. His career and life came to a tragic end in 1976 when he was robbed and shot to death near his home in College Park, Georgia.

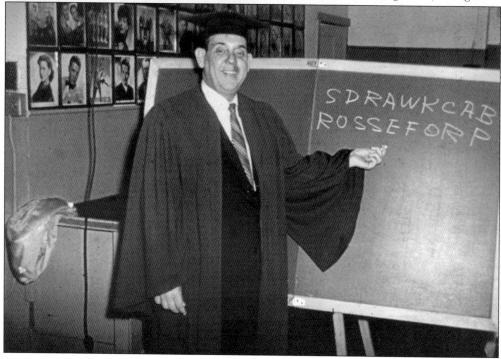

King of the banjo, Eddie Peabody played the four-string plectrum banjo so skillfully that some listeners thought he was playing two banjos. Peabody had played vaudeville, served in both world wars, made records, went on television, appeared in movies, and conducted a nightclub circuit in the 1950s. Sadly, the most famous banjo player of his generation would die from a brain hemorrhage on stage at Covington's Lookout House in 1977.

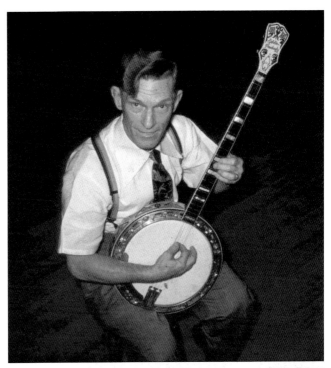

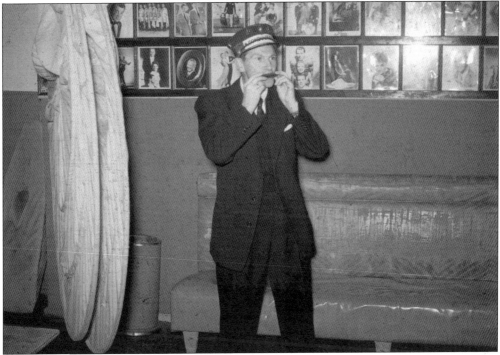

An audience would not see this kind of supporting act today. As this "railroad conductor" played harmonica, lamps on his hat lit up and steam blew out of the top. To the left are the giant hoopskirts the dancers wear in the show. Beside them is an ironing board that has seen better days in the hands of the wardrobe lady.

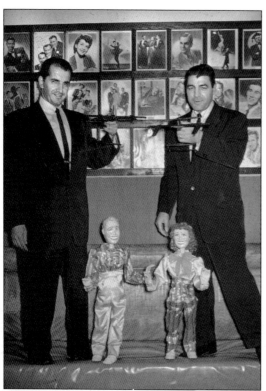

Marionettes today have been relegated mostly to children's theater. In the 1950s, however, the puppet act performed by the Martin Brothers appeared in clubs, on the stage, and on television. In modern times, marionettes are seen in Hollywood films like *Sound of Music* and *Team America: World Police*.

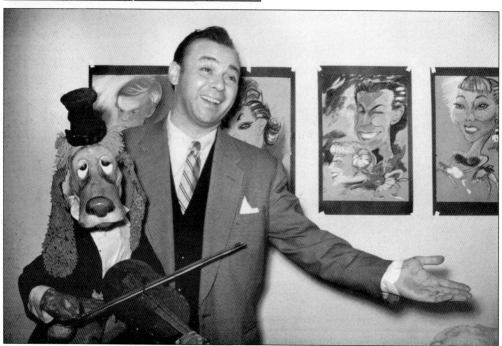

Among the multitudes of novelty acts was La Moret. This talented performer did a ventriloquism show with a puppet dog that played the violin. During Moret's two-week stint, he drew caricatures of club employees, which are proudly hung on the wall behind him.

Considered politically incorrect and possibly racist today, marionettes of puppeteer Victor Charles were not only commonplace, but they were not considered racist in the 1950s. After the civil rights movement of the 1960s, old-fashioned puppets like these disappeared.

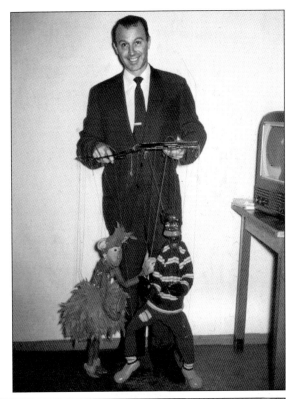

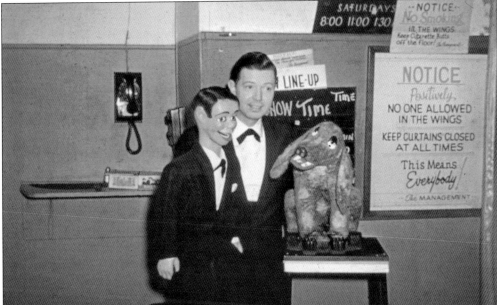

After hosting a children's show on television in New Jersey, Jimmy Nelson brought Danny O'Day (left) onto the nightclub circuit in the 1940s. After his ventriloquism act made it into large New York theaters, he added the dog, Farfel. His appearance on the *Milton Berle Show* made him a national hit. In 1955, he and Farfel made commercials for Nestle, one of the longest advertising campaigns on television: "Chawk-lit!" Note the signs on the backstage wall.

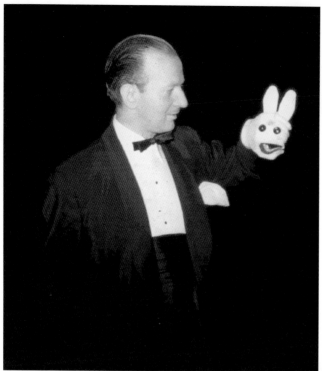

Some puppeteers did not need marionettes and strings. Mr. Ballentine wore a glove, attached ears, and with some makeup, he had a talking rabbit hand puppet. His act was similar to the more-famous Señor Wences, a ventriloquist who appeared frequently on the *Ed Sullivan Show*. Señor Wences drew a face on his hand, placed it on top of a doll, and spoke for it in a falsetto voice.

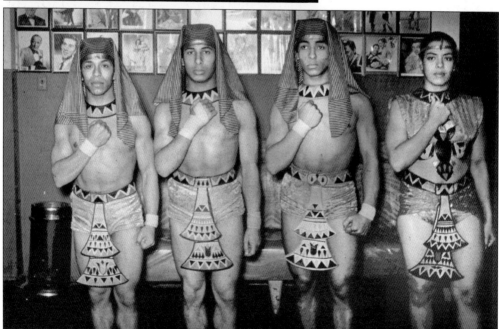

Supporting acts came from all around the globe. The Ramses was an international acrobatic team from Egypt. In this circus quartette, three men would throw the woman into the air and catch her when she completed her trick. This act required speed, timing, coordination, and limberness. There were no safety nets; the men were totally responsible for the woman's safety. Their coordinated effort made for a thrilling 15-minute show.

Four

TIME FOR REHEARSAL

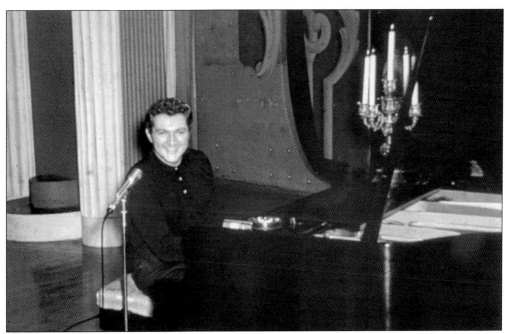

Rehearsals took place every other Friday from 1:00 p.m. until 5:00 p.m. and usually were casual affairs. Liberace (Wladziu Valentino Liberace) was a superstar when he appeared at Beverly Hills. He was also a down-to-earth man who the musicians found charming and approachable. A Las Vegas regular, he had recently played Madison Square Garden in 1954. Liberace rehearses here on a house piano and has provided his own gold microphone and candelabra. His cigarettes lie beside the ashtray.

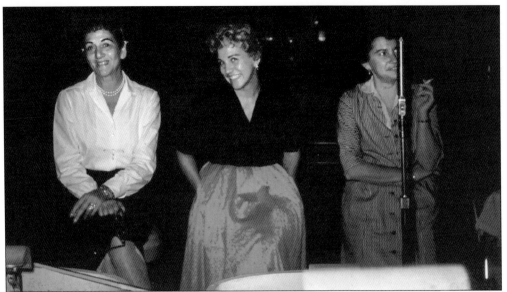

The Andrews Sisters were a worldwide sensation with hits including "Boogie Woogie Bugle Boy," "Don't Sit Under the Apple Tree," and "Shoo-Shoo Baby." They had performed with all the major big bands and had appeared in a number of movies. When they stopped by Beverly Hills during their 1956 nightclub tour, they were the best-selling female vocal trio of all time. From left to right, LaVerne, Patty, and Maxene Andrews relax with a cigarette during a rehearsal break.

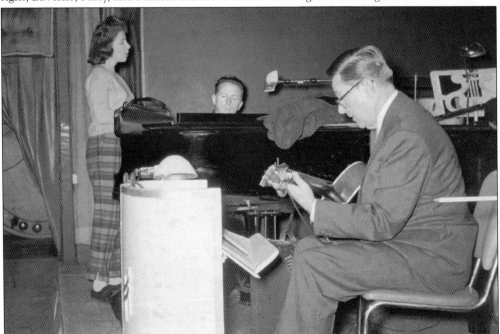

Irish singer Carmel Quinn (left) came to the United States in 1955 and appeared on the *Arthur Godfrey Talent Scouts* radio show. After winning, she became a regular on his show. She went on to make numerous appearances on 1950s television shows, including *Arthur Godfrey* and the *Today Show*. Here she rehearses while Gardner Benedict plays accompaniment and her personal guitarist strums along.

The old vaudevillians Benny Fields and Blossom Seeley came to Beverly Hills about four years before Fields's death. Fields and Seeley performed comic patter and sang duet numbers from the 1920s and 1930s. In their heyday, the popular pair made records and appeared in a few Vitaphone subjects. Here they prepare to rehearse for what is probably among their last public shows.

Many acts wore business attire during rehearsal. With cigar firmly clenched in his teeth, comedian and ventriloquist Dick Drake plays his mandolin as Gardner Benedict accompanies him.

A common sight on the nightclub stage during the 1950s was an acrobatic act. The Musical Wades was a five-member family that played 18 different instruments, did vocal numbers, tap dancing, baton twirling, comedy, and acrobatics, including a unicyclist.

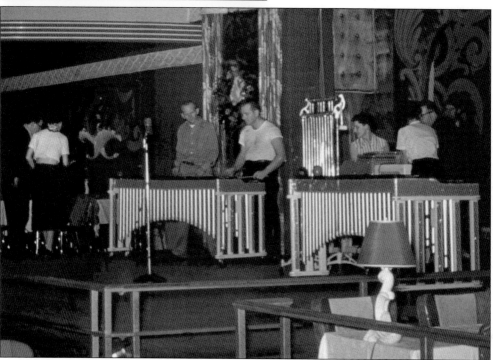

The chimes and vibraphones were part of the music of the Musical Wades, a typical vaudeville-style act. Here two members are practicing the vibraphones as the others continue to set up for rehearsal.

Novelty acrobatic acts like the Musical Wades often got their start performing in circuses before moving out on their own. Other times they grew up in families that had roots in vaudeville. In the early 20th century, unicycle riding on stage was as common as ballroom dancing in the 1950s.

Most of the orchestra watch the leotard-clad dancers rehearse. The stage's proscenium changed occasionally through the years. This is an early version before Beverly Hills started bringing in larger shows.

Broadway actress and singer Lisa Kirk pauses to review her stage positions with her manager. The orchestra behind them takes a break, which gives Clark an opportunity to snap a quick photograph. By this time, Kirk had appeared on Broadway in *Allegro* and *Kiss Me Kate*. Later she would return to the stage and become a regular at the Persian Room in New York City's Plaza Hotel. She recorded a few solo LPs and died in 1998.

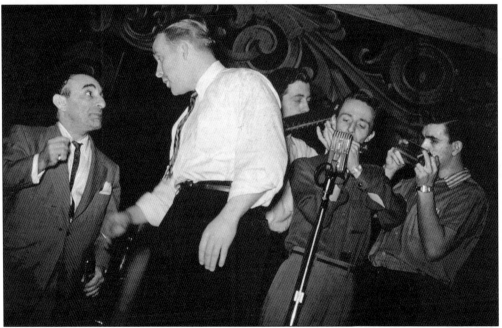

Standing at less than 5 feet tall, Johnny Puleo (left) speaks with the stooge during a rehearsal of the Harmonica Rascals. Puleo played harmonica and acted with wild physical comedy in the Harmonica Rascals' supper club tours of the 1950s. Often Puleo surprised the audience after the show started by popping out from beneath a dancer's hoopskirt.

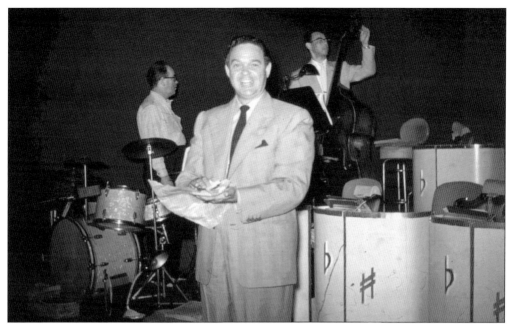

The career of operatic tenor James Melton took off after his 1938 performance in *Madame Butterfly* with the Cincinnati Zoo Opera Company. Through the 1930s, he was on radio and in motion pictures. He was making records, singing at nightclubs, and starring on television by 1951. Here he enjoys a tuna sandwich after having just arrived. Behind him are house musicians Ted Tillman (left) and Bud Ruskin adjusting his bass.

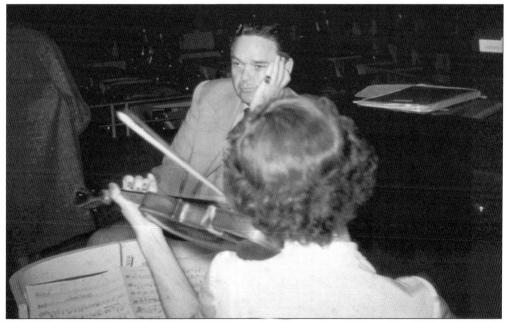

Travel fatigue has caught up to James Melton after having flown in an hour before rehearsal. Here he struggles to keep his eyes open as a violinist plays an arrangement from *Sweethearts*. An avid car enthusiast, he later opened the Autorama auto museum in Hypoluxo, Florida. It closed following his death in 1961.

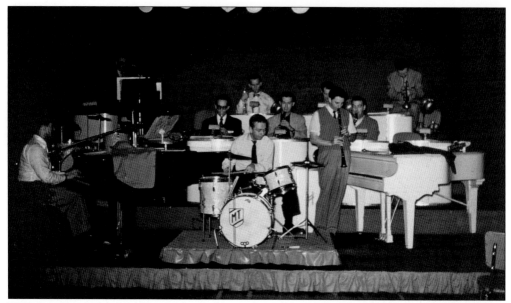

With his tenor voice, Mel Torme charted a number of hits in the 1940s. "Careless Hands" went to No. 1 in 1949. In the 1950s, the Velvet Fog recorded his own arrangements of popular tunes and toured nightclubs. The versatile performer played a variety of instruments and here demonstrates his percussion skills. The white piano and custom drum kit were part of his show. His conductor, Al Peligrino, plays clarinet beside him.

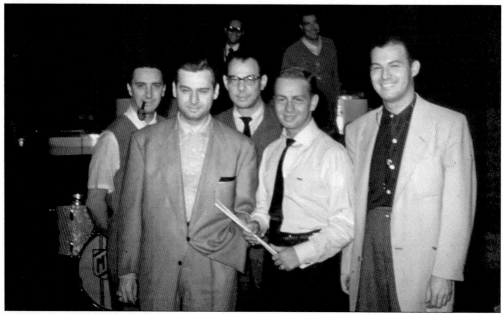

Mel Torme was around 30 years old when he played Beverly Hills. During rehearsal break, he poses with the house band. Pictured from left to right are Al Peligrino, Bill Mavity, Bud Ruskin, Mel Torme, and Earl Clark. Jim Langenbrunner (left) and Hap Seaman are standing on stage behind them. Torme reemerged in the 1970s and gave more than 200 live performances. He appeared on television in the 1980s and 1990s, recording more albums and performing live until his death in 1999 at age 73.

Above, everyone took a break and relaxed with coffee in the middle of rehearsal. Irish singer Carmel Quinn, seated at the rear table, chats with Gardner Benedict. Drummer Shooky Shook stands at far left in the white shirt and tie. Pictured in the foreground, from left to right, are Hap Seaman, Dick Westrich, and Andy Jacob (seated). Fritz Mueller stands at the right while a few other employees sit and talk.

At right, this coffee break around 1960 shows how the decor inside Beverly Hills has changed, the most obvious changes being the furniture. Starring this week was 20-year-old singer Anita Bryant, at right. A few years earlier she had sung on Arthur Godfrey's radio show and was crowned Miss Oklahoma in 1958. By this time, she had at least four songs in the Top 100. Across from her, from front to back, are Marty Weitzel (seated), Bill Rank, and Frank Gorman.

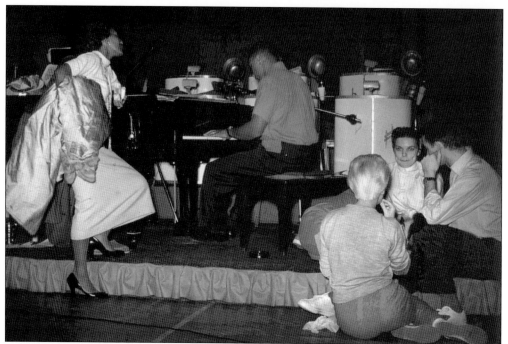

The "Bronze Bombshell" Joyce Bryant wore tight, revealing dresses while performing on stage. This four-octave singer made records in the early 1950s, and a photograph spread of her appeared in *Life* magazine in 1953. Here Bryant has just arrived for rehearsal; she holds her coat while singing an impromptu number. Seated at the right are dancers taking a rehearsal break.

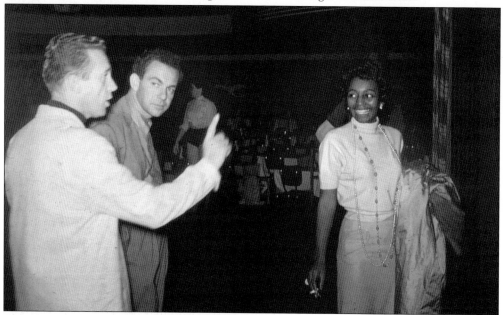

Joyce Bryant is now leaving to put down her coat. On the way, she lit a cigarette and started chatting with Gardner Benedict at left. To Benedict's right is the featured comedian Jack Carter, who had recently appeared on Broadway opposite Sammy Davis Jr. in the musical *Mr. Wonderful*. Bryant's radiant smile shows why she was considered one of the most beautiful African American women in the world.

At age 20, Vivian Della Chiesa was singing opera professionally. Through the 1940s and 1950s she performed on stage, for network radio, and in nightclubs. In the 1960s, she made a few records and hosted the *Afternoon Show* on WLWT in 1967. Here she smiles while the musicians shuffle through their music. Facing her is WLWT star Buddy Ross. The seated accordionist is Frank Gorman. Della Chiesa died in 2009 at age 94.

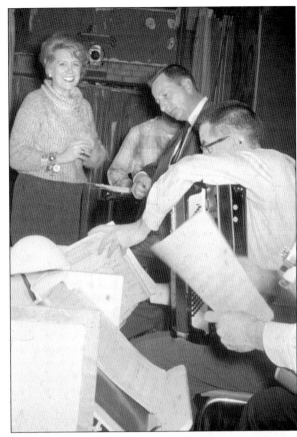

When Shecky Greene rehearsed, he believed this much bawdier preview was better than his live performance. Greene started in Las Vegas in 1953 telling jokes, stories, and improvised songs while dancing on stage. He made a few films and played the nightclub circuit around 1955, appearing at Beverly Hills three different times. He went on television in the 1960s, and a racehorse was named for him in the early 1970s. He still performs in Las Vegas today.

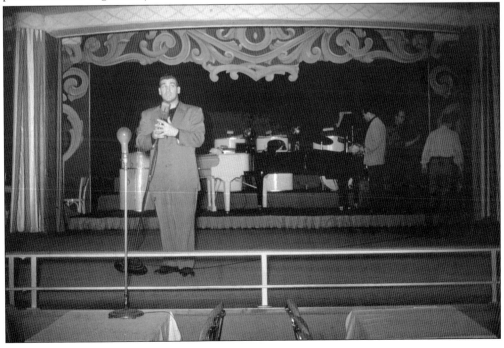

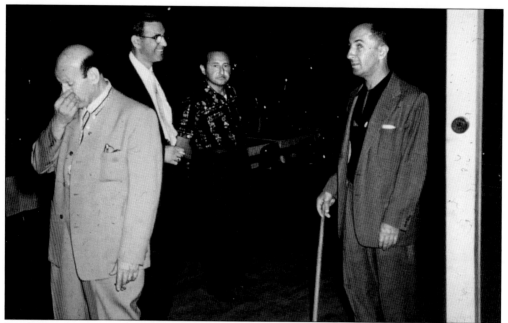

By playing drums in a comedy band in the 1920s, Ben Blue (holding a prop cane) entered show business. He headlined at Hollywood's Slapsie Maxie's in the 1940s after appearing in films. While featured on television, he performed in Hollywood and San Francisco nightclubs. Beverly Hills manager Garson Tucker (second from left) dropped by to meet him during a 1952 rehearsal. Blue appeared in movies and on television until his death in 1975.

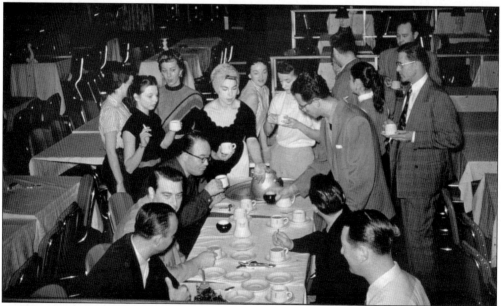

The Goofers are taking a rehearsal break. This novelty group was made up of members of the Louis Prima Band with lead man Jimmy Vincent. The only Goofer present at this moment is bandleader Frank Nichols, leaning over the table on the right. The local dance group, the Lindsay Lovelies, is gathered at the rear of the table, and at the far right is Bill Rank. Orchestra musicians are sipping their coffee at the forefront.

Five

GATHER 'ROUND THE PIANO

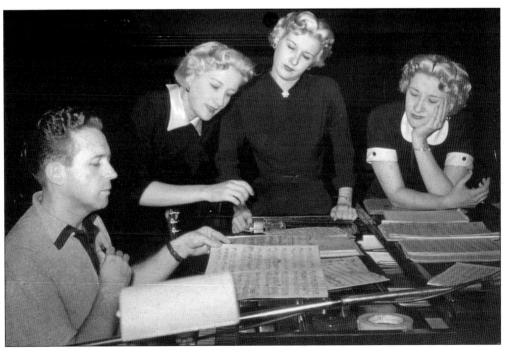

The Los Angeles trio the Del Rubio Triplets toured nightclubs in the 1950s and 1960s singing and playing guitar with their own unique style. They unexpectedly reemerged in the 1980s, now in their 60s, appearing on television wearing miniskirts, go-go boots, and big blond hairdos. Audiences watching *Night Court*, *Pee-Wee's Playhouse*, and *Married . . . with Children* fell in love with them all over again. Here they review their music with Gardner Benedict when their act was still fairly new in the 1950s.

Show-business veteran Beatrice Kay (second from the left) headlined with a 1920s-style song and comedy act. By the 1950s, she had appeared in burlesque, vaudeville, theater, radio, movies, records, and television. Well-traveled in all the finest clubs, she had appeared at the Moulin Rouge in Paris, Ciro's in Hollywood, and the El Rancho in Las Vegas. She died in 1986 at age 79.

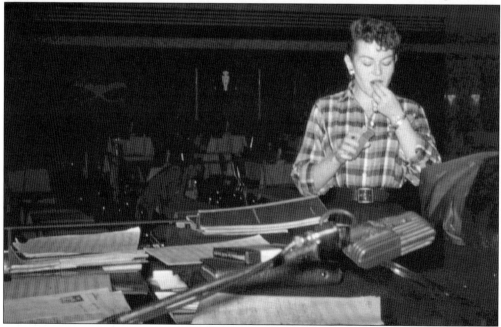

Las Vegas nightclub singer Beverlee Dennis cools her throat with a lozenge. Heavy singing was hard on vocal cords and often required soothing medication. She developed a solid career and appeared a few times on the *Ed Sullivan Show*. She retired from singing in 1958 to marry New York restaurateur Hank Soloff. In her later years, she ran the Coach and Six restaurant in Atlanta, Georgia.

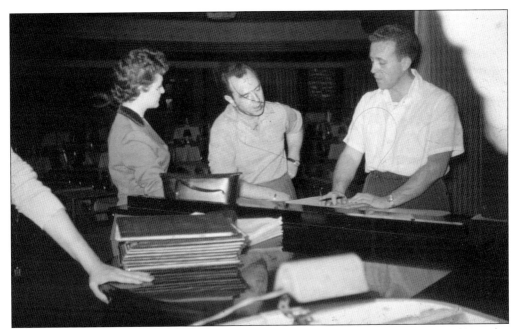

Headlining this week is Dolores Hawkins, a singer in Gene Krupa's orchestra. To her right, Hawkins's conductor, jazz great Boyd Raeburn reviews music cues with Gardner Benedict. Piled on the piano in the foreground are the music books for each song in the show. Each musician will be issued his own book.

Comedian Buddy Hackett (left) pauses in mid-routine as Gardner Benedict explains what Hackett may be doing wrong. In his younger years, Hackett honed his skills in the Borscht Belt nightclub circuit in the Catskills. By the mid-1950s, Hackett was an established movie actor, had appeared in Los Angeles and Las Vegas clubs, and on *Jack Paar* and *Arthur Godfrey*. His roles in *It's a Mad Mad Mad Mad World* and *The Love Bug* were still a decade away.

Funny-man Buddy Lester was a show-off during rehearsals. Here he performs an act in which he will play the trumpet, seen resting on the piano. Gardner Benedict waits to play the music for *Clair De Lune*. Lester later appeared in a number of films, working with Jerry Lewis the original *The Nutty Professor* and alongside Frank Sinatra in the original *Ocean's Eleven*.

Actor and comedian Jack E. Leonard holds a cigarette and stands prominently as he breaks from rehearsal. Leonard was a rising star during the 1950s and became a nightclub and television headliner following visits on Jack Paar's *The Tonight Show*. On stage he wore horn-rimmed glasses and an undersized suit. He was renowned for insult humor years before Don Rickles. At left is Andy Jacob. An unidentified club employee emerges from the wings, laughing at Leonard's latest quip.

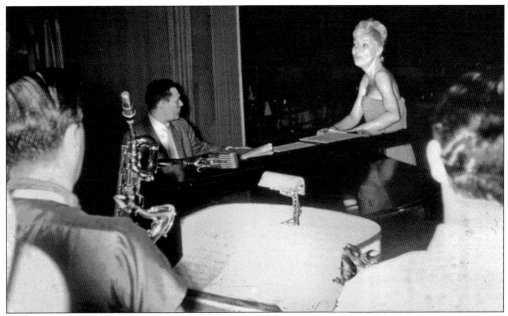

Broadway musical star Carol Channing was well known for her role in *Gentlemen Prefer Blondes*. Channing was notorious for wearing outrageous costumes to rehearsals, which sometimes consisted of a simple, colorful sarong. Saxophonist Hap Seaman is at far left, and seated at the piano is Channing's conductor. Clark stands to the far right. Seaman would later die in the 1977 Beverly Hills Supper Club fire.

Now wearing a glittery dress during another day's rehearsal, Carol Channing watches her husband and manager, Charles Lowe (in the black shirt), argue with the production singer at right. Pianist Jack Rusin smokes a cigarette and waits. Channing would go on to appear in numerous Broadway shows and films, and might be recognized by modern audiences for a satirization in a 2006 episode of *Family Guy*.

Beverly Hills featured a wide range of talent, including Lauritz Melchior (far left). Hailing from Copenhagen, Denmark, Melchior made his debut as a baritone singer in 1913 in *Pagliacci*. By this time, he was a world-famous opera tenor and is best remembered for his tenure at the Metropolitan Opera Company, where he had performed from 1926 to 1950. By 1952, Melchior had appeared in five musical movies as well as numerous times on television.

Lauritz Melchior typically traveled with a group of musicians, including a conductor, a male singer, and a female soprano. Here the soprano rehearses under the direction of Melchior's conductor. Alongside the hundreds of famous celebrities, Melchior's handprints and footprints can be seen in the forecourt of Grauman's Chinese Theater in Hollywood. Shows like his brought class to Northern Kentucky.

Another opera star was Helen Traubel, a powerful soprano who had enjoyed a long career at New York's Metropolitan Opera (Met) beginning in 1937. While she was the leading soprano at the Met in 1941, she and Lauritz Melchior sang with NBC Radio's Symphony Orchestra, which was conducted by Arturo Toscanini. In the 1950s, she went on supper-club tours and appeared in films and on television shows, including the *Red Skelton* and *Perry Como Shows*. She continued making public appearances until her death in 1972.

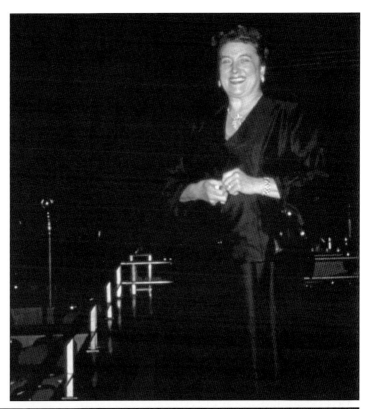

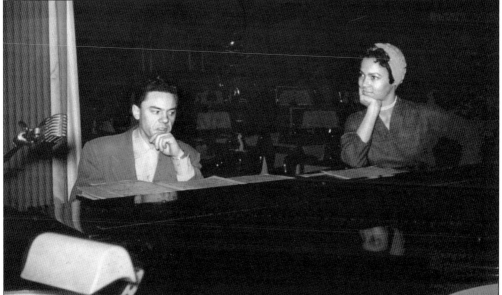

By the time Dorothy Dandridge appeared at Beverly Hills, she had received an Academy Award nomination for Best Actress for her role in the 1954 film *Carmen Jones*. While appearing on the silver screen, she was touring nightclubs. Here she discusses the songs she plans to sing as her conductor, Hank Shank, reviews the score. She would later die due to an accidental overdose of medication at age 42.

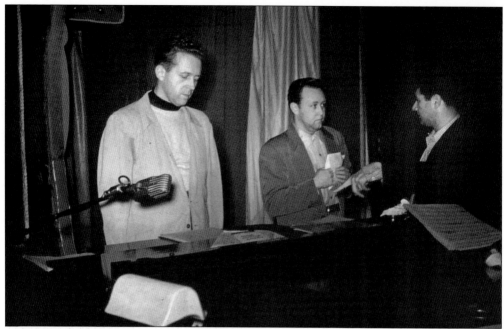

Barely seen at the far right is actor/comedian Dick Shawn, who had appeared on Broadway, in movies, on television, and as a stand-up comic in nightclubs throughout the world. Shawn is well remembered for his roles in *It's a Mad Mad Mad Mad World* and as the beatnik in the 1968 film *The Producers*. At center is master of ceremonies and production singer Jimmy Burton. Gardner Benedict stands ready at the piano. Shawn later died on a California stage in 1987.

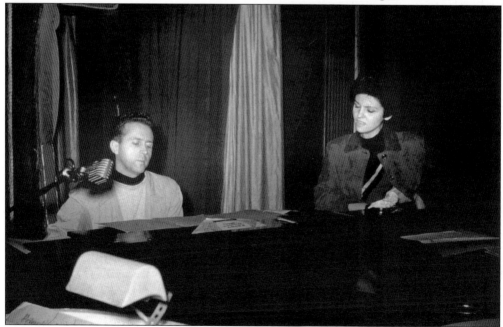

Although Lois Ameche was not as famous as some of those who took the stage at Beverly Hills, pianist Gardner Benedict gave her and every act his undivided attention. Ameche, a minor headliner, rehearses her music while still wearing a jacket and gloves.

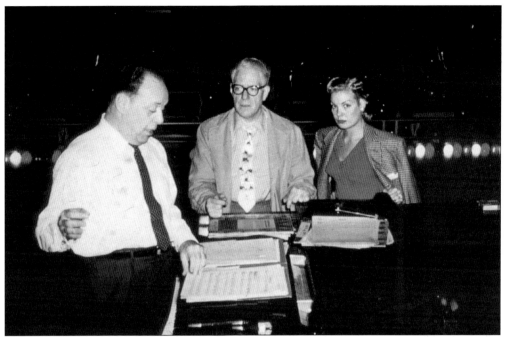

Singer and movie star Nelson Eddy reviews the score with his conductor Ted Paxson at the piano. Eddy's screen-partner Jeanette MacDonald left him following a long film career. In 1953, he started a nightclub act with Gale Sherwood (right), who gives the camera a wry look. Eddy always filled every house he played. Until his death in 1967, he bore his amazing resemblance to his Royal Canadian "Mounty" character.

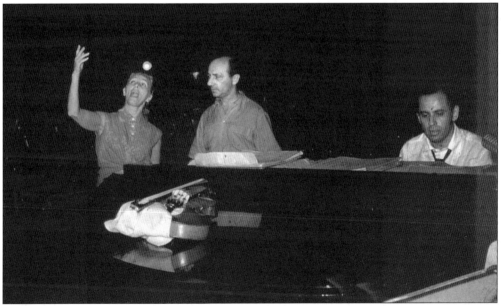

Patti Moore and Ben Lessee were a duo that performed an old-time vaudeville-style act. They are seen here rehearsing around the piano. Shows like theirs demonstrate the diversity of acts that appeared on stage at Beverly Hills, common then, but unusual to today's crowds. Larry Green (right) was their indispensable conductor and pianist.

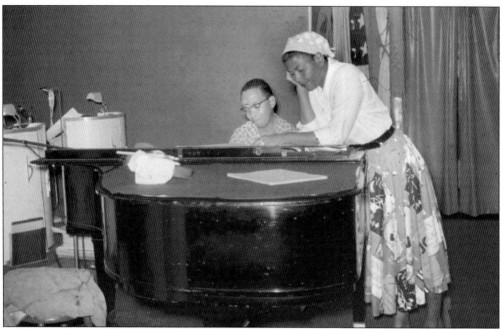

The world-famous Pearl Bailey started in vaudeville and made it to Broadway in 1946. She performed in nightclubs in the 1940s and toured with the USO. During the 1950s, she starred in movies and made records. Her 1952 recording of "It Takes Two to Tango" went to No. 7 on the charts. Bailey is seen here at Beverly Hills reviewing her music with her pianist. African American performers were encouraged not to mingle with the audience and instead remained backstage during intermissions.

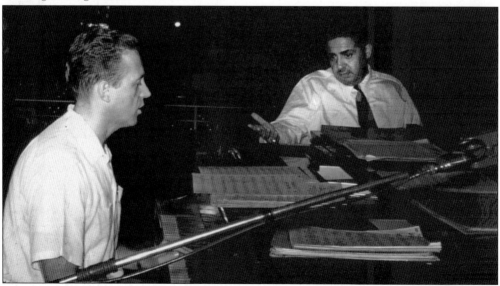

Italian comedian Romo Vincent (right) was a character actor in a number of films and television shows by the time he came to Beverly Hills. He tickled the audience with his songs and comedy routines that included bits from his movie roles as policemen and cab drivers. Here he rehearses with Gardner Benedict. He went on to appear on television and in small parts in movies through the coming years.

Six

THE COUCHES AND PHOTOGRAPH WALL

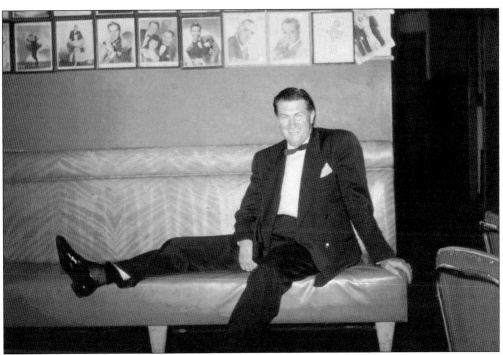

"Ladies and gentlemen, welcome to the Showplace of the Nation!" When master of ceremonies Art Craig Mathues wasn't relaxing, he was on stage greeting the audience and introducing the shows. After each segment finished, Mathues would dash out, tell everyone to give it up for the last act, and bring out the next one. The couch he is resting on is one of three that were located backstage. From superstar headliners to dog-show supporting acts, everyone used the couches.

The Borscht Belt in New York's Catskill Mountains served as a training ground for actors and comedians during the first half of the 20th century. Theaters built in Hunter, New York, served the local camps and hotels. Among the hundreds of A-list entertainers who honed their skills in the Borscht Belt was this Jewish sister-act, the Barry Sisters, comprised of Claire and Myrna Barry.

Virtuoso piano showman Liberace is dressed in a sequined tuxedo and smokes one more cigarette before taking the stage. Beverly Hills delivered the top names in entertainment, and he was one of the biggest who appeared there. He was earning over a million dollars a year in public performances. After he played in Cuba in 1956, he went on a European tour and met with Pope Pius XII. Liberace soon incorporated more glitz and glamour into his act, calling himself a "one-man Disneyland."

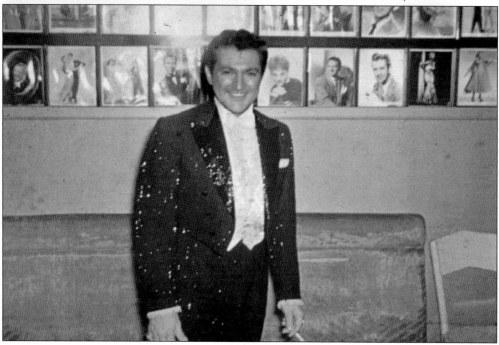

Alan King left boxing to become a Jewish comic while working the Borscht Belt in the 1950s. Focusing his act on suburban life, he won over the audiences and inspired future comedians. King had recently appeared in the film *Hit the Deck* and was a regular on the *Ed Sullivan, Perry Como,* and *Garry Moore Shows*. Here the headliner relaxes with a cigar while wearing a bathrobe between shows. Modern audiences may recognize him from the 1995 film *Casino* and 2001's *Rush Hour 2*.

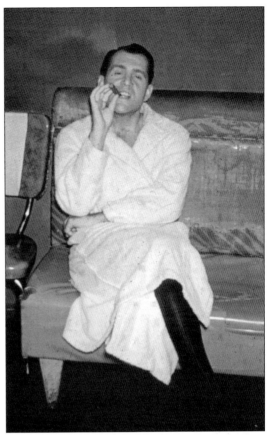

When Tony Bennett appeared at Beverly Hills, his career was just getting off the ground. His first No. 1 hit record was 1951's *Because of You*, followed by *Blue Velvet* and *Rags to Riches*. He developed a nightclub act and knocked the audiences' socks off at Beverly Hills. His style suffered through the rock-and-roll era, but he made a huge comeback in the 1980s and 1990s, appealing to all new audiences. His version of "I Left My Heart in San Francisco" remains one of the 20th century's most enduring hits.

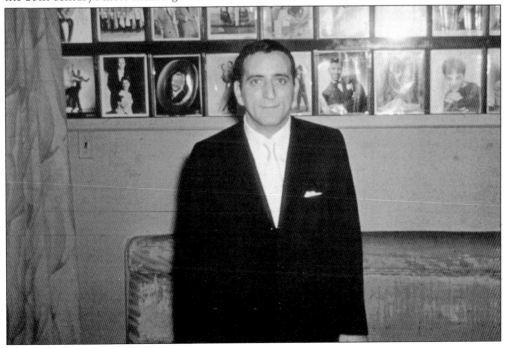

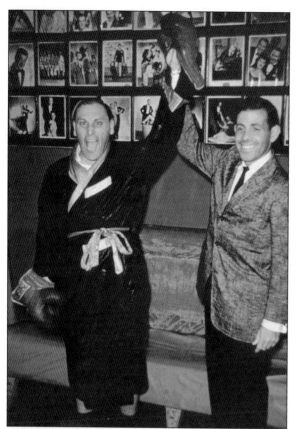

One of the many comedy teams to play Beverly Hills was Davis and Reese, made up of Pepper Davis (left) and Tony Reese. Davis and Reese was a Las Vegas favorite that took their act on the road nationwide. They appeared on television in the 1950s and 1960s until they went their separate ways in 1964. Both continued to appear on television separately for the rest of their lives.

Scottish born and raised, singer Ella Logan performed in English music halls and toured Europe. After immigrating to the United States in the 1930s, she appeared in movies and on Broadway and entertained the troops during World War II. In 1947, she was in Broadway's *Finian's Rainbow*, singing "How Are Things in Glocca Morra." During this time, she became an international nightclub act appearing at New York's Copacabana and the Waldorf-Astoria. Leaning against the wall at the far left are two hoopskirts worn by the dancers.

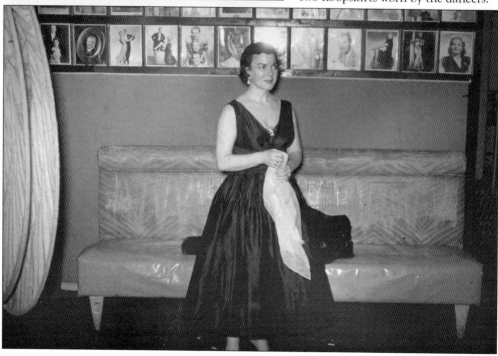

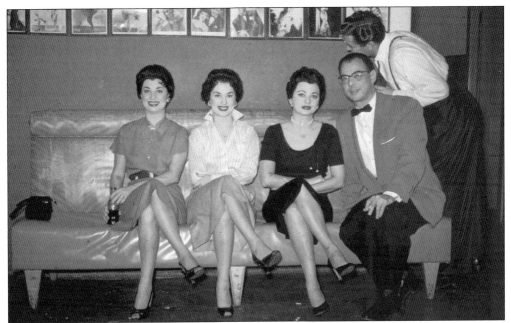

Peggy, Cherie, and Babette DeCastro made up the Latin American singing combo, the DeCastro Sisters. This Cuban version of the Andrews Sisters incorporated comedy, dancing, and energy in their act and appeared in movies and on television in the 1940s and 1950s. They recorded music from 1952 to 1962, charting a hit song in 1954 with "Teach Me Tonight." Joining them on the couch is bass player Bud Ruskin. Production singer Dick Hyde searches behind the couch for his missing wallet.

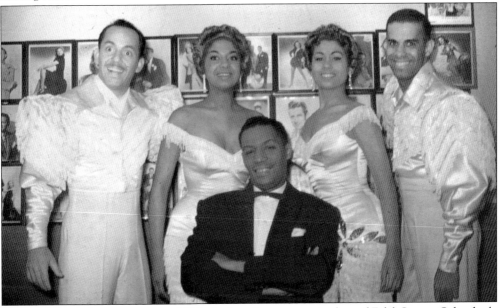

Fantastic musical acts came out of Cuba before the communist days of Fidel Castro. Orlando de la Rosa, in the tuxedo, headed this dance team that played in nightclubs from coast to coast in the 1950s. A musical quartet as well as dancers, the group recorded several hits during the peak of their popularity.

Comedy acts appearing at nightclubs often consisted of husband-and-wife teams. Here Don Rice poses with his wife, Kitty Barrett, before their turn on stage. Rice had toured solo in the USO during the war but sometimes brought his wife along. When they performed together, Rice was the star while Barrett played the stooge, or "straight woman."

Seen earlier at rehearsal, Clark catches Dorothy Dandridge checking out the wall of photographs of the entertainers who had played Beverly Hills. Before coming to Southgate, she had appeared in a number of movies. Her earliest was a small part in a 1935 *Our Gang* short. Later she was in the 1937 film *A Day at the Races*. One of her last roles was as Bess in the 1959 film *Porgy and Bess*, for which she received a Golden Globe award nomination.

After leaving the chorus line at New York's Roxy Theater, Fran Warren became a featured vocalist with the big bands of Art Mooney, Charlie Barnet, and Claude Thornhill. Her recording of "A Sunday Kind of Love" made the charts in 1947. Warren appeared at Beverly Hills shortly after starring in the 1953 Broadway revue *Danny Kaye* and *The Pajama Game* in 1954. She later toured with Harry James in the 1960s and landed the title role in the 1983 revival of *Mame*.

Quartets were the most common acts that appeared at nightclubs in the 1950s. Like so many others, the name of this one has been forgotten. This starlet was perhaps not quite ready for the camera in this scene. In the days before digital photography, there was no way to know how the picture would look until later.

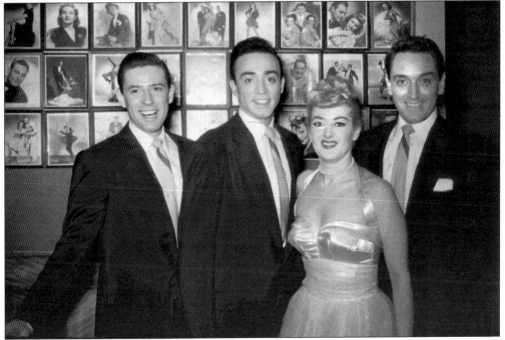

Georgia Gibbs's earliest stage performance was in an orphanage variety show. Later she went on to a huge career singing with big bands and on the radio. While she toured with Sid Caesar and Danny Kaye, her first hit came in 1950 with "If I Knew You Were Coming, I'd Have Baked a Cake." Her first No. 1 hit was "Kiss of Fire" in 1952. She continued making records and had more than 40 charted hits through the 1950s.

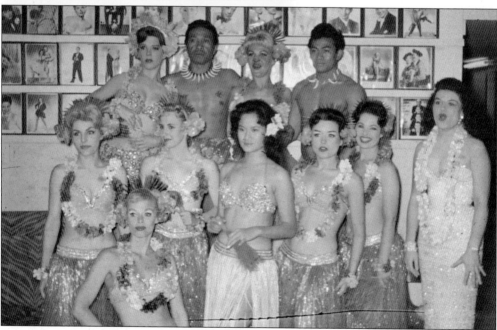

On rare occasions, Beverly Hills would set aside its usual show lineup and dedicate an entire night to one event. This Samoan group presented a traditional Hawaiian revue and luau complete with hula girls, a fire dance, and even an outdoor pig roast for the staff. Several Beverly Hills dancers augmented the show's troupe.

As a young man, Guy Marks discovered a knack for imitations of sounds and impersonations of his friends. He went into stand-up comedy and became a world-class impressionist. He hit the nightclub circuit, came to Beverly Hills in the early 1950s, and left everyone in stitches. Marks composed "Loving You Has Made Me Bananas," a one-hit-wonder novelty tune and spoof of the hotel bands of that era. He became a TV actor from the 1960s until the 1980s.

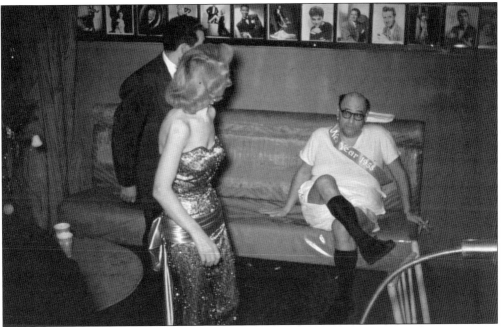

On New Year's Eve 1957, insult comic Jack E. Leonard had the unpleasant duty of playing Baby New Year. In this show, not seen much today, someone in a long beard and holding a scythe represented the "Old Year" just before midnight. After the clock struck 12, Leonard pranced out on stage clad only in a diaper and sash to officially bring in the New Year. He unhappily relaxes here with a cigarette as the Riveras, of the Tippy and Cobina act, check him out.

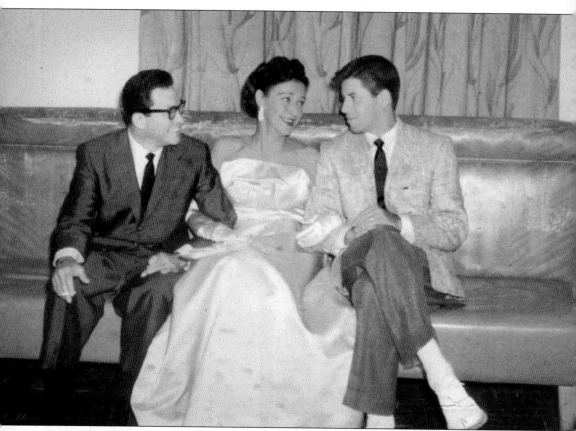

Actor and comedian Jerry Lewis (right) was visiting in Cincinnati. He dropped by Beverly Hills to meet with his friend actress Jane Froman, who was headlining that evening. Froman had appeared on the stage and in films since the 1930s. As a singer, she had put out a number of hits. While entertaining in the USO in 1943, she nearly lost her leg when her airplane crashed. After a long recovery, she made more records and went on television programs, including *Texaco Star Theater* and *Toast of the Town*. From 1952 to 1955, she starred in her own *Jane Froman Show*. She played Beverly Hills during a nightclub tour soon after. It is obvious here she would like to spend some time with Lewis. The featured comedian, Johnny Kaye, (left) is trying unsuccessfully to move in on Lewis's action.

Ballroom dancing was as popular live in the 1950s as it is on television today and will shortly be performed on stage by John and June Belmont. June looks especially dazzling in her resplendent yellow evening gown. They had been relaxing on the couch reading *The Kentucky Post* when Clark asked them for a photograph.

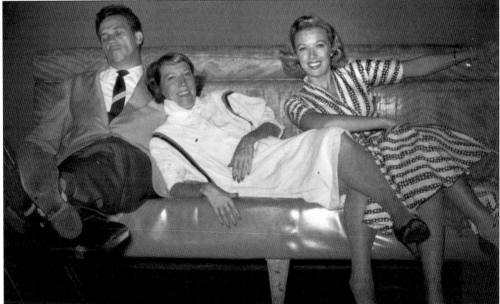

Beverly Hills trumpet player Wally Hahn, snoozing at far left, shares couch space with the Kean Sisters. Musicians sometimes worked day jobs, so they often slept when they could, in this case, beside Betty Kean (left) and Jane. The Kean Sisters were a comedy duo who played the nightclub circuit in the 1940s and 1950s, but Jane turned to television after their appearance in the 1955 Broadway musical *Ankles Aweigh*.

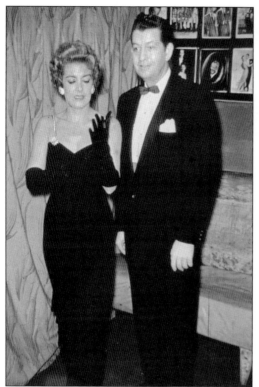

Headliners ranged from movie stars to performers climbing the ladder of success. Jon and Sondra Steele were a married act who sang soft, sentimental ballads in sweet harmony. Their biggest, and perhaps only hit, was their cover of "My Happiness" in 1948. This tune had been recorded by a number of artists, but the Steele version went all the way to No. 3. The song refused to die, having been rerecorded many times over the coming years, including once by Elvis Presley.

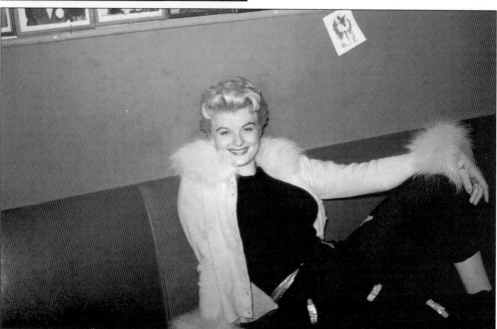

Her name is forgotten, but Clark recalls this woman as the stooge in a comedy duo in one of the supporting acts. Known also as a "talking lady," she was required to be both good looking and quick-witted. Also a decent singer, she is seen with the Intermission Trio on page 14. Here she rests on the couch before her show.

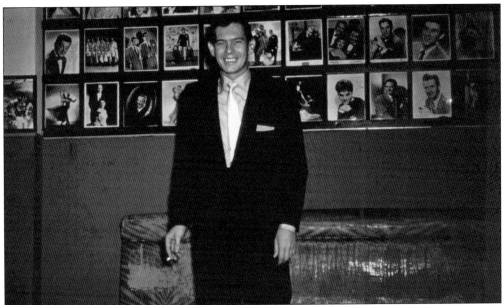

Johnny Ray became a teen idol in 1951 for his hits "Cry" and "The Little White Cloud That Cried." Ray had a unique rhythm-based vocal style, and his onstage antics included beating the piano and writhing on the floor. At Beverly Hills, he was the only performer Clark knew who smashed his dressing room mirror in a fit of rage. He would continue to make records in the 1950s and appeared on television through the 1970s.

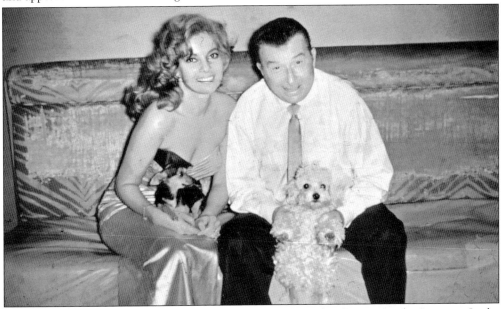

Today's audiences might be familiar with Xavier Cugat through references in the *Simpsons*. In the 1920s, the Spanish bandleader helped spread Latin American music into the United States. He appeared with his orchestra in 1930s films and was making records in the 1940s. His trademark on stage was holding a Chihuahua with one hand while waving a baton with the other. He sits here on the couch before his show with his wife, singer Abbe Lane. His would later be married to the spicy Latin singer Charo.

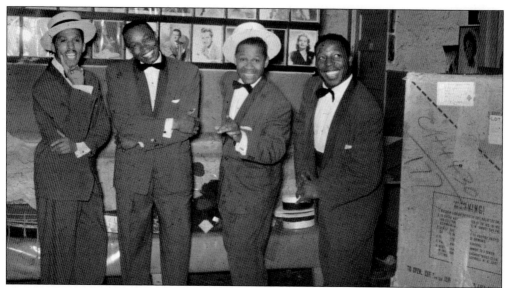

The first African American tap-dancing act to appear at both Radio City Music Hall and on television was the Four Step Brothers. Three friends started a dancing trio in Charleston, South Carolina, in 1925. Before long, they performed at the Cotton Club in Harlem and then in vaudeville and nightclubs. When a fourth member was added in 1927, they were billed as "Eight Feet of Rhythm." They specialized in flash tap, a high-powered kind of dancing mixed with acrobatic stunts. They were considered top performers in their field.

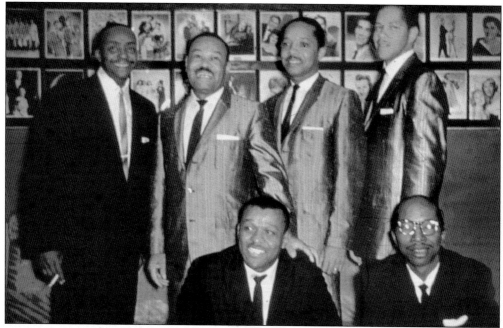

Waco, Texas–born Billy Williams (far left) joined three other singers in 1950 to perform on Sid Caesar's *Your Show of Shows*. The new Billy Williams Quartet made a number of recordings with a style that fell between pop and rock-and-roll. Their biggest hit was "Wheel of Fortune," released in 1952. The harmonizing quartet added two more members, kneeling forefront, to play piano and guitar.

A minor scandal ensued in Cincinnati when the well-known African American opera singer Arthur Lee Simpkins danced with local television personality Ruth Lyons on her show in the mid-1950s. Stars appearing at Beverly Hills were often invited to be a guest on *Ruth Lyons*. In his younger days, Simpkins sang vocals for the Earl Hines Orchestra, and by this point, he was doing popular versions of operatic arias. A Beverly Hills favorite, he had appeared there a number of times. Here Simpkins (left) stands ready beside his pianist.

Beverly Hills hosted hundreds of vocal quintets struggling to make it in the business, including the Visionaires. However, nothing is remembered of this group that played the nightclub circuit in the 1950s.

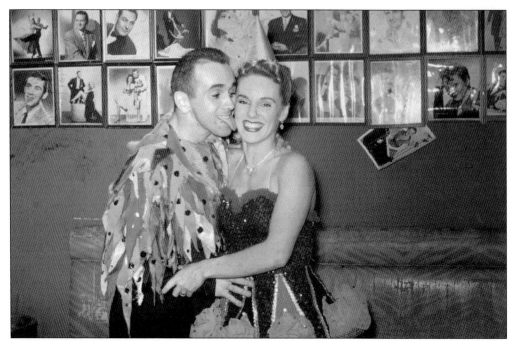

Public displays of affection were just as common in the 1950s as they are today. This husband-and-wife team performed an acrobatic and ballroom dance act with a bit of comedy thrown in. When Clark grabbed the camera, these two showed they were not shy about canoodling with each other backstage.

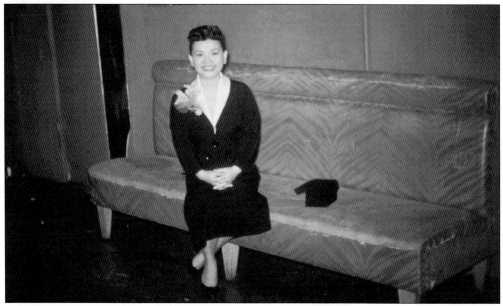

The vinyl couches beneath the walls of photographs showed heavy abuse. For years, they were subjected to rips, fluid spills, cigarette burns, and the wear from the posteriors of those who sat on them while waiting for their turn on stage. Here "Natalie," the lead singer from the Hawaiian musical group the Beach Combers, perches on the edge, as if not wishing to absorb any of the stains from the couch's unforgiving past.

Seven
Paparazzi Shots

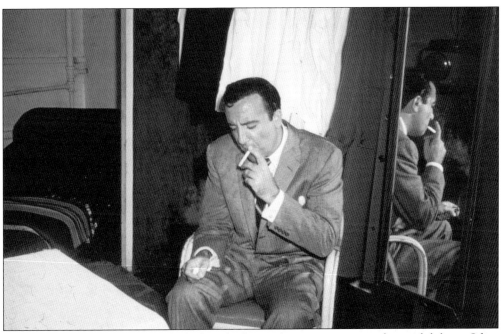

Backstage Beverly Hills provided Clark with plenty of ripe opportunities for candid shots. Often the entertainers were preparing for their shows or just relaxing with a smoke. Big-band singer Don Cornell had to leave the Sammy Kaye orchestra to fight in World War II. After his discharge, he rejoined the band, then went solo in 1951 to make more records and go on the *Arthur Godfrey*, *Perry Como*, and *Ed Sullivan Shows*. Before long, he was headlining at supper clubs nationwide. Here at Beverly Hills, he enjoys a cigarette before his show.

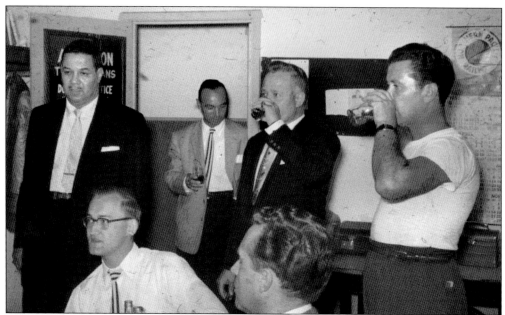

Probably best remembered for his 1950 hit "That Old Black Magic," William Boone "Billy" Daniels is standing second from right, drinking bourbon and soda with the musicians in 1955. Daniels was one of the first African American entertainers to leave the big band for a solo career and the first to star in his own television show, *The Billy Daniels Show*, in 1952. Pictured from left to right are (seated) Dick Westrich and Gardner Benedict; (standing) Daniels's conductor, Andy Jacob, Billy Daniels, and master of ceremonies and production singer Dick Hyde.

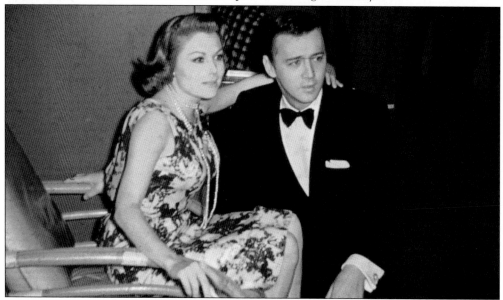

World-famous tap dancer Bobby Van started his career as a trumpet player, comic, and impressionist. While playing a venue in the Catskills, he wowed the audience by subbing for another act with a song and dance routine. From that point on, he was a dancer. He appeared in films, including *Kiss Me Kate* in 1953, and hit the nightclub circuit, dancing at Beverly Hills shortly after. Here he and his wife, movie starlet Diane Garrett, wait for his call while seated near the furnace backstage.

Ohio native Bob McFadden was a supporting-act comic at Beverly Hills. The audience especially loved the funny vocal sounds he could make. Later, in the 1960s, McFadden would move to New York to become one of the most successful voice-over talents in television history. He was famous for his voice of a parrot in a Wisk commercial: "Ring around the collar." Here McFadden is in his dressing room holding a prop book, ready to take the stage to open for the main attraction.

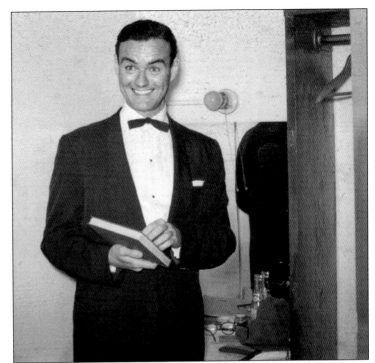

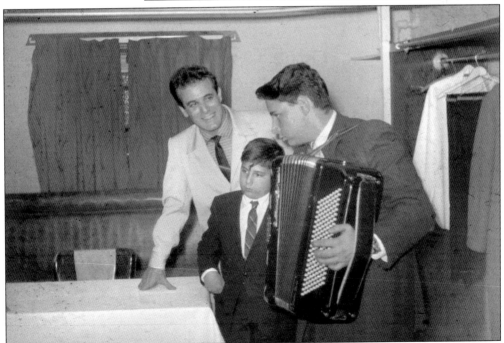

In the late 1940s, Dick Contino was billed as the "world's greatest accordion player." After serving in the Korean War he took to the nightclub circuit in 1954. While at Beverly Hills, he agreed to meet a local accordion player. Here Contino (left) listens enthusiastically as the boy's younger brother stands by. Contino appeared on television and in the 1958 film *Daddy-O*, which was mystified on *Mystery Science Theater 3000* in 1991. Contino still performs today.

They were like the Jonas Brothers of the early 2000s, like the Backstreet Boys of the 1990s, and the New Kids on the Block of the 1980s. In the pre-rock years of the 1930s and 1940s, vocal groups were the heartthrobs of the day. Four brothers of the Mills family in Piqua, Ohio, formed a vocal quartet and played the Midwest theater circuit. In 1928, these talented young men became radio stars on Cincinnati's WLW. When the Mills Brothers signed a contract with CBS, they became the first African American performers on network radio. Their records were smash hits, and their 1952 release of "Glow Worm" went to No. 1, soon followed by "You're Nobody 'Til Somebody Loves You." When they played Beverly Hills, they had two hours between shows. Despite their superstar status, they remained backstage during intermissions. Seated, clockwise, are Herbert Mills, Harry Mills, and their father, John Mills Sr. Don Mills sits at rear right, and standing is their guitarist, Norman Brown.

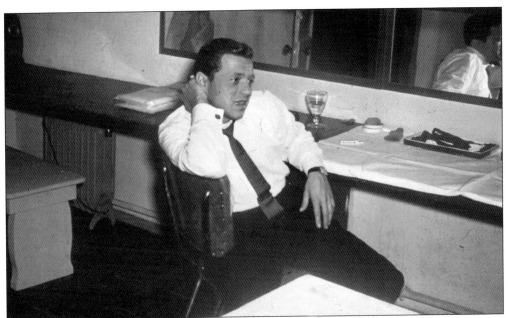

When pop singer Steve Lawrence sang at Beverly Hills in early 1957, his marriage to Eydie Gorme was several months away. He had recorded a few solo albums and went on television, where he eventually partnered with Eydie Gorme. Since then, either solo or with Gorme, he has performed in nightclubs, concert halls, television, and movies, including *The Blues Brothers* in 1980. Here the 32-year-old singer chats with someone off camera as he waits for his show.

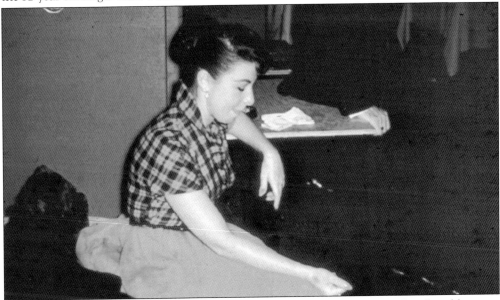

A month after Steve Lawrence's appearance at Beverly Hills, Edyie Gorme headlined her own show. She had sung for the Glenn Miller Orchestra, and by 1957, she had recorded four albums. Here Gorme relaxes by the furnace (a Chrysler Airtemp), seemingly unaware that Clark has taken the photograph. She made a few more solo records and went on permanent tour with her husband as the act Steve and Eydie. Their marriage and partnership is one of the longest-lasting celebrity matchups in history.

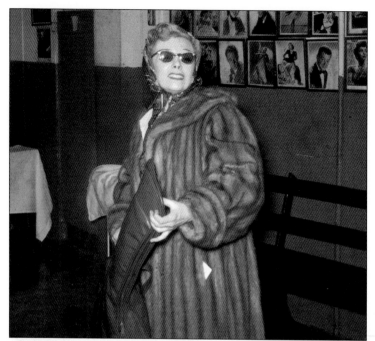

Organist Ethel Smith had appeared in a few movies in the 1940s. Her 1944 recording of "Tico Tico" went to No. 14, selling over a million copies. A featured singer and organist on Lucky Strike's *Your Hit Parade*, she made a career playing pop music on the Hammond organ. She recorded dozens of albums and published a music instruction book. Clark has caught her on her way out of Beverly Hills, wearing her fur coat and carrying the guitar she played on stage.

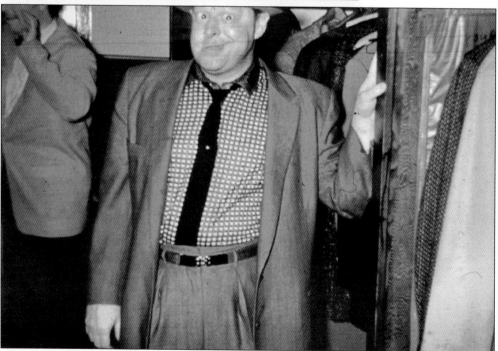

Revered for his goofy mannerisms, Frank Fontaine entertained millions on both radio and television. He played wacky characters that audiences loved, notably "John Silvoney," a tipsy bum on radio's *The Jack Benny Program* and "Crazy Guggenheim" on television's *The Jackie Gleason Show*. He has brought his usual antics to Beverly Hills, caught here at his dressing room doing his "Guggenheim" character. One of the musicians chats with someone off camera, unaware of what is going on nearby.

More common today, but surprising in the 1950s, was for female African American entertainers to marry white men. Superstar singer and actress Pearl Bailey rehearses her show as her husband, jazz drummer Louis Bellson (far right), looks on. At the back left, Gardner Benedict obviously enjoys the performance given by Bailey's piano player.

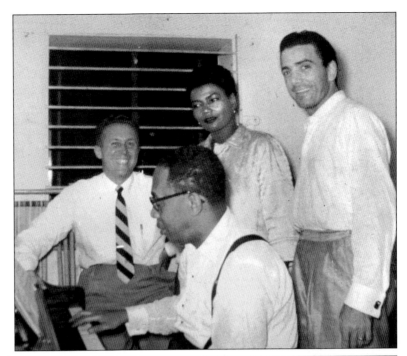

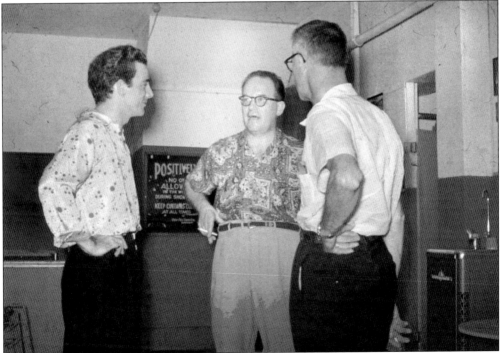

One of the top drummers in the world, Louis "Louie" Bellson (left) swaps war stories with Beverly Hills' drummer Ted Tillman (center) and Bill Rank. Bellson was visiting his wife, Pearl Bailey, instead of entertaining the audience with his unforgettable percussion rhythms. He played for all the legendary big bands and appeared at the White House almost as often as Bob Hope. More than a dozen instruction books on percussion bear his name. He continued to perform until his death in 2009 at the age of 84.

Ripley's Believe It or Not once timed violinist Florian Zabach's speed as he played *Flight of the Bumblebee* and counted 12.8-notes per second, "faster than any known violinist in history." His 1951 recording of "The Hot Canary" sold over a million copies. He appeared on nearly every program on television and hosted his own national television show, the *Florian Zabach Show*. When he came to Beverly Hills, Clark snapped this surprise photograph in Zabach's dressing room.

Hal LeRoy moved from Cincinnati to New Jersey in 1928 to become a professional tap dancer. With newfound success, he appeared in a number of stage shows and films during the 1930s. Through the 1940s, he did summer stock, played Radio City Music Hall, and went on television. After appearing in *Show Boat* in 1956, he tap danced on the stage of Beverly Hills. Before LeRoy went on, Clark caught him in his dressing room enjoying a cigarette.

When singer and comedian Joe E. Lewis refused to renew his contract at one of Al Capone's clubs in 1927, he was severely beaten by George "Machine Gun" Kelly. This encounter left Lewis with a permanent scar on his face. He appeared in films in the 1930s and 1940s, toured with the USO during World War II, and was on all of the popular television shows of the 1950s. At Beverly Hills, Clark has found Lewis reading a letter before his show; his head is turned to hide the scar. Frank Sinatra played Joe E. Lewis in the movie *The Joker is Wild*.

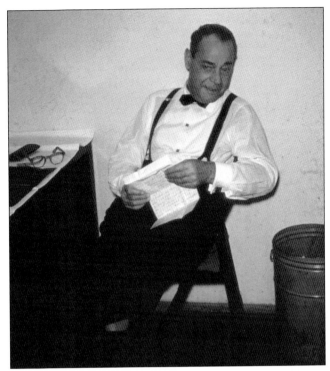

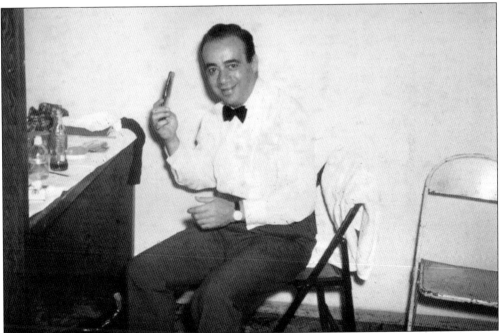

Primping here in his dressing room is comedian Gene Baylos. He was known mostly throughout the nightclub circuit and was a favorite of New York celebrity comedians. He first went on television in 1949, and through the coming years, he landed small roles in various series until the 1970s. As he prepares for his show at Beverly Hills, Baylos enjoys a Coca-Cola from the backstage machine. He died in 2005 at age 98.

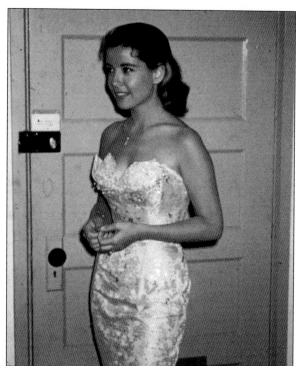

When Charlie Chaplin needed a child actor for his 1936 film *Modern Times*, he cast Gloria DeHaven in her first feature role. In the 1940s and 1950s, she became a name actor and a star on the silver screen. She worked mostly minor roles on television from the 1950s to 2000. Clark snapped this photograph during her nightclub tour as she prepared to leave her dressing room to head for the wings. One of her last roles was in the 1997 feature *Out to Sea* with Walter Matthau and Jack Lemmon.

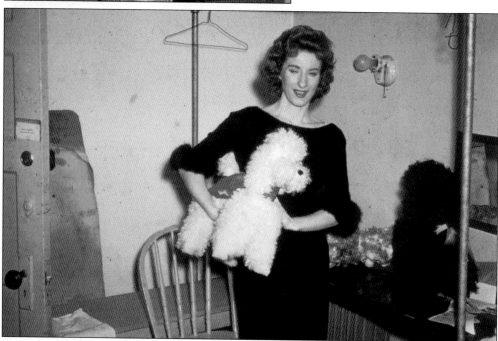

The Irish singer Carmel Quinn, seen earlier in rehearsal, is at her first appearance at Beverly Hills. Here she is in her dressing room, holding a stuffed dog sent to her by an admirer. Since the 1950s, Quinn has recorded a number of records and CDs. She still performs at nightclubs, supper clubs, benefit concerts, and, occasionally, on television. The ironing board seen previously leans against the wall behind her.

Does anyone remember the days before cellular phones? In the 1950s, people did not have the same opportunities for constant contact as they do today. There was exactly one telephone booth backstage for general use. Between shows, the receiver was rarely on the hook, just as when Clark caught this unnamed performer in mid-call.

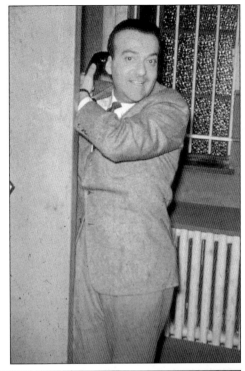

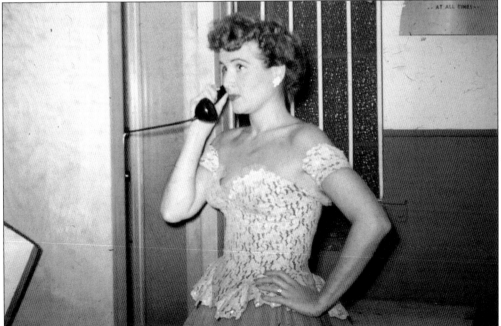

At age three, "Baby Rose Marie" Mazetta was performing in vaudeville. In 1928, she went on NBC radio at the age of five and, before long, was starring in talking films. After 1934, she dropped "Baby" from her name and went on the road. A nightclub headliner in her late teens, she opened Las Vegas's Flamingo Hotel in 1946 then appeared on film, Broadway, and television. She would play Sally Rogers on the *Dick Van Dyke Show* and later starred on *Hollywood Squares*.

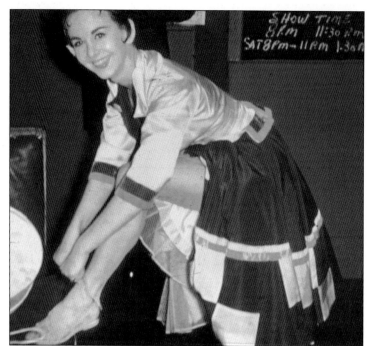

A regular dancer at Beverly Hills, prima ballerina Marlene Powers was usually only seen dancing in the ballet production numbers before the main act. As the prima dancer, she was the featured solo ballerina at Beverly Hills. She left the nightclub to star in European ballet and settled in Hamburg, Germany. Here she laces her shoe prior to going on stage. The schedules for the 14-day shows are written on the blackboard behind her. A grueling schedule was a part of the business.

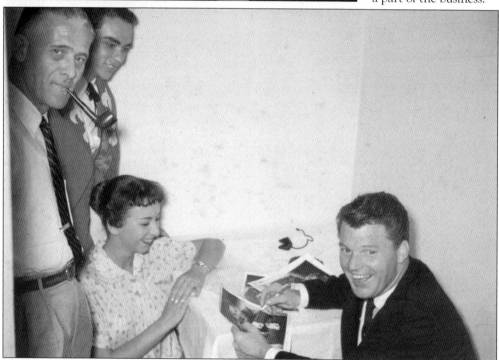

Most entertainers carried photographs to sign for their fans. Here Rusty Draper, one of the biggest country and pop singers of the 1950s, signs one for Marlene Powers. Waiting their turn are Bill Rank (far left) and the production dancer. Draper sang on country radio in the 1930s before moving west to sing in San Francisco clubs. In 1952, he released his debut album and went on television and a national nightclub tour. He would sell more than 31 million records in his career.

"If you die in the elevator, be sure to push the Up button." One of the most-often quoted personalities in history, humorist Sam Levenson taught school before he became an entertainer. Stories from those teaching days went into much of his stand-up comedy act. By the early 1950s, he was on television shows, including *What's My Line* and *The Steve Allen Show*. In his dressing room at Beverly Hills, Levenson horses around with his suspenders as he dresses for his show.

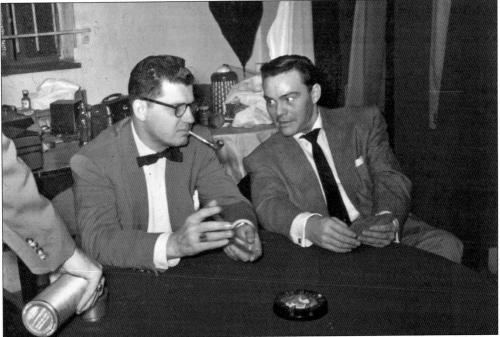

Paul Gilbert was one of the guys. When he came to Beverly Hills, audiences recognized the featured comedian from his appearances on television's *The Spike Jones Show, The Colgate Comedy Hour,* and *Toast of the Town*. He also liked to hang out with musicians, being a trumpet player himself. In this candid moment, Gilbert (right) played cards and talked shop with Charlie Medert, a house trumpet player. Medert was a professional musician and the head of the music department at Madeira High School.

Rocky Cole (center) has dropped by the musicians' dressing room to offer bottles of liquor to the musicians at the end of the two-week run. This customary gift sometimes consisted of jewelry or cigars. Cole was the conductor for the singing duo the Kean Sisters, seen earlier resting on the couch on page 73. Accepting the present are Fritz Mueller (left) and Frank Bowsher.

In the late 1940s, the dance team of Raul and Eva Reyes was one of the most popular Cuban acts in the country. Specializing in the rumba, they brought their Latin American dancing style to television and nightclubs nationwide. In the days when Cuba was a popular vacation spot, the Reyeses were familiar crowd-pleasers. Here Eva enjoys a cigarette as they review the music for their show.

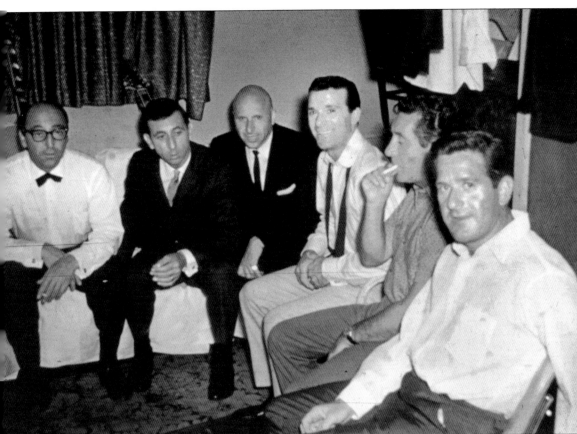

All 1950s nightclubs were inundated with quartet harmony groups, but few could entertain like the Vagabonds. Throughout the 1940s and 1950s, they appeared at every nightclub in the country, and the seats were always full. The Vagabonds combined music with comedy, often with such deadpan expressions the audience did not know whether or not to laugh. But they always did. Pictured from left to right are Tillio Rizzo, on accordion; Eddie Peddy, who replaced Pete Peterson on bass; Lenny Leavette, drums; Dominic Germano, on guitar; Al Torrieri, on guitar; and Babe Pier, comic and impressionist. They had appeared on 1940s radio on the *Bob Hope Show*, *Frank Sinatra*, and *Abbott and Costello*, and in a number of films as well. After the war, they were regulars on television's *Arthur Godfrey*. They were actually unable to read music yet could play practically anything. They also had their own supper club in Miami, the Vagabond Club. Here the Vagabonds relax in the large dressing room between their shows.

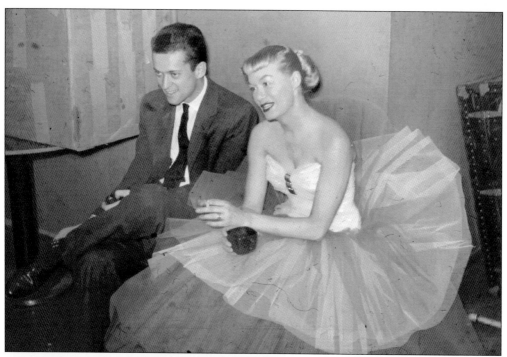

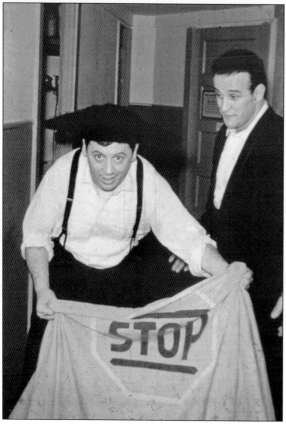

When Anita O'Day left the Stan Kenton Orchestra in 1945, singer Shirley Luster got the role of lead vocalist and changed her name to June Christy. Almost overnight, her songs such as "Shoo Fly Pie and Apple Pan Dowdy" and the 1945 million-seller "Tampico" were radio favorites. Christy went solo in 1948 as a cool jazz artist and appeared at Beverly Hills when her hugely successful 1954 album, *Something Cool*, premiered. Here she relaxes backstage with coffee and a cigarette while her accompanist enjoys a pipe.

Judging by the "STOP" cape and the black matador-style hat, comedian Marty Allen was perhaps rehearsing a bullfighter routine with his partner, Mitch De Wood. Allen appeared near the front of the nightclub bill as a show opener and would later become a fixture in Las Vegas. He was well known for his partnership with Steve Rossi, but before that, he and Mitch De Wood were a comedy duo whose humor was reminiscent of Martin and Lewis.

Eight

MAY I TAKE YOUR PICTURE?

Performers at Beverly Hills loved the camera. They never minded when Clark would approach them and ask for a picture. Whether the entertainers were club regulars or Hollywood headliners, if there was a camera present, they availed themselves. Here production singer Clay Mundy and prima ballerina Marlene Powers strike a pose. They would use it in their Spanish-themed opening number that will kick off this night's show lineup in just a few minutes.

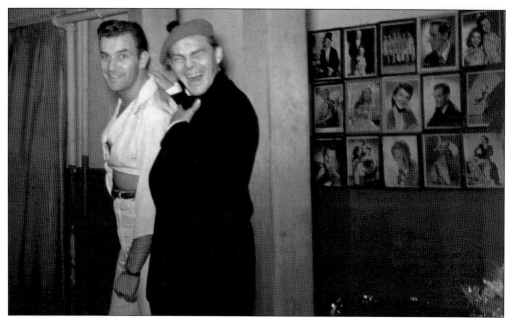

Paul Gilbert (right), who was last seen hanging out in the musicians' dressing room on page 91, is ready for his show but stops to give Art Johnson, that night's production singer, a big pat on the back. Gilbert was the adoptive father of Melissa Gilbert, who played Laura Ingalls Wilder on *Little House on the Prairie*. He died in 1975 at the age of 57.

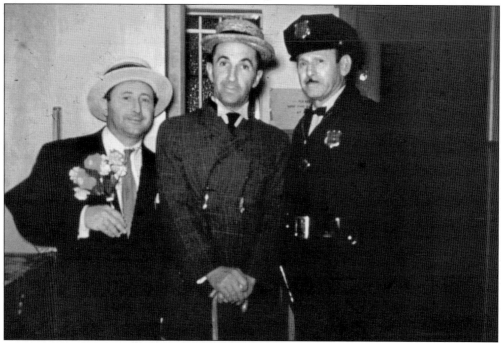

Still carrying the prop cane he used in rehearsal, Ben Blue (center) is ready to begin his vaudeville-style show. With him are his stooges, bit movie actor Sammy Wolfe (left) and Sid Fields. A veteran comedy actor, Fields was on the *Abbott and Costello Show* and had recently appeared in the film *Las Vegas Shakedown* in 1955.

Dressed in a green gown and long white gloves, singer Betty Madigan looks as glamorous as Elizabeth Taylor. Sadly, Madigan would never achieve that kind of success. She had appeared in a few recent television shows, including *The Colgate Comedy Hour*. When she came to Beverly Hills, her 1954 single of "Joey" had gone to No. 12. Her only other hit would be her 1958 recording of "Dance, Everybody Dance." She poses here in front of a standard backdrop being stored backstage.

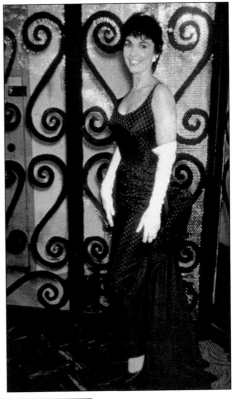

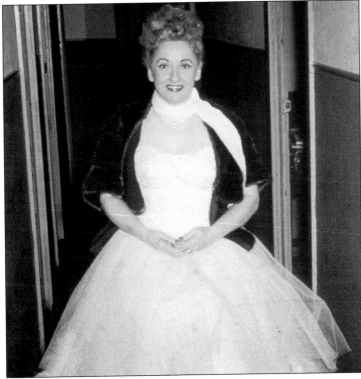

In 1936, the national singing trio the Boswell Sisters broke up when two of the sisters retired. When Connee Boswell went solo, she became one of the greatest jazz vocalists of all time. Her 1939 duet with Bing Crosby, "An Apple for the Teacher," went to No. 2. Due to a childhood ailment, Connee could not walk, so she spent her entire life performing from a chair. In the 1950s, she went on television and nightclub tours to keep her career alive. Connee is pictured here seated beside the musicians' dressing room.

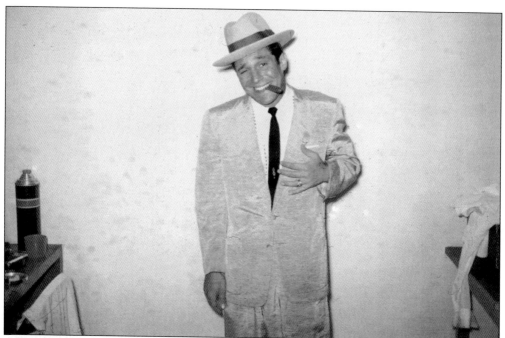

Comedian Bobby Sargent was enjoying a cup of coffee and a cigarette when he was interrupted in his dressing room. He stuck his prop cigar in his mouth and donned his hat to get into character for the photograph. On stage, Sargent told funny stories of his native Pittsburgh, especially about the recent arrivals to the steel mills, using accents from the old country.

Comedian and movie actor Buddy Hackett (right) has changed into his tuxedo and is ready to go on stage. But first he reviews the lighting arrangements with technician Lester Webb. Hackett's first movie appearance was in a 10-minute short in 1950. During this time, he had an active nightclub career and would star in his next picture, the 1953 musical Walking My Baby Back Home. It was not until his guest appearances on 1950s television programs that a national audience recognized him.

The "Poet of the Piano," Carmen Cavallaro (left), was one of society's favorite entertainers. An unidentified member of his 14-piece orchestra on the right also points to the camera. Cavallaro released a number of albums and toured nightclubs in the 1940s and 1950s, stopping at Beverly Hills to perform lush, classical piano themes in pop arrangements. Legendary piano showman Liberace once said that Cavallaro was one of his influences. Cavallaro spent his golden years in Columbus, where he died in 1989.

Wearing a slinky red dress and holding a feather fan, singer Cathy Carr is ready to take the stage. Carr toured with the USO during the war and sang with Sammy Kaye's orchestra and other big bands. She started making records in 1953, but it was not until she signed with Cincinnati's Fraternity Records in 1956 that she recorded her only hit, "Ivory Tower." Her following releases consisted mostly of teenage pop songs until her last one in 1967.

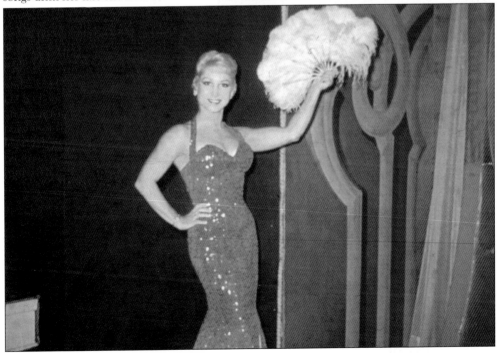

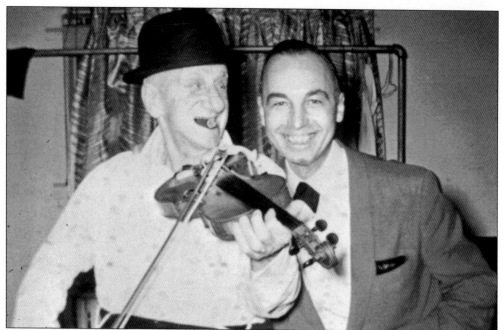

A returning favorite at Beverly Hills was the ol' Schnozzola, Jimmy Durante (left). The actor, musician, comedian, writer, and singer with a gravelly voice had been in a number of movies and television shows by the time he reached Southgate. A vaudeville headliner and radio star, his 1934 novelty hit "Inka Dinka Doo" became his theme song. In his dressing room, Durante poses beside violinist Andy Jacob with Jacob's violin. Durante is best known by modern audiences for the 1969 holiday classic *Frosty the Snowman*.

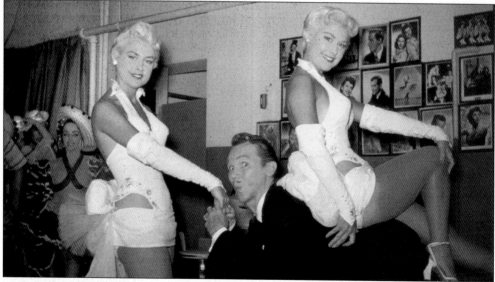

Minutes before hitting the stage, this comedy act holds their slightly uncomfortable pose so Clark can take their picture. The two dancers in white were twin sisters. While on stage, the designer between them draped elaborate bolts of cloth over them while they performed their routine. Behind them, the showgirls are taking their positions in the back left as they watch this group with mild amusement.

After immigrating to the United States in 1949, accomplished Hungarian dancer Francois Szony formed the Dancing Szonys. Over the following years, he danced with a series of female partners, including his wife, Giselle, seen here wearing an orange dress and standing backstage with Francois. Famous for his spectacular adagio lifts, Francois Szony appeared nationally at all of the biggest clubs, including San Francisco's Bimbos 365 and the Latin Quarter. The one-of-a-kind dance team also appeared on television shows, including *Toast of the Town* and *Dinah Shore*.

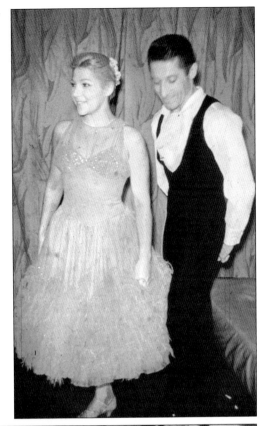

Eileen Barton was born into a family of vaudevillians. At two and a half years old, she sang "Ain't Misbehavin'" on stage, and by 1932, she was a radio star. Through her teen years, she sang for the big bands and was making records by 1948. Her 1949 recording of "If I Knew You Were Comin' I'd've Baked a Cake" went to No. 1. She hit the nightclub circuit and appeared on television's *Morey Amsterdam Show* and *Jack Carter*. Here Barton checks out the wall of performers who came to Beverly Hills before her.

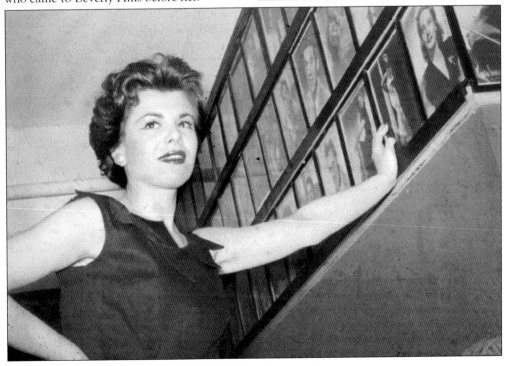

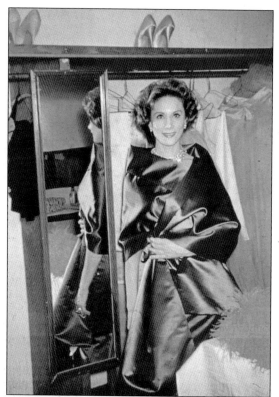

A Broadway star by the time she came to Southgate, Dorothy Sarnoff studied in France in 1935. She played Rosalinda in *Die Fledermaus* with Philadelphia's New Opera Company in 1941. In 1950, she was Lady Thiang in *The King and I* on Broadway and appeared in *My Darlin' Aida* in 1952. When she came to Beverly Hills to sing opera, Clark found her in her dressing room wearing a delightful green wrap, preparing to take the stage.

Seen previously in rehearsal, Shecky Greene is ready to take the stage. The comedian grabbed two showgirls to share the moment when Clark asked for a picture. Greene looks back on his experience at Beverly Hills as "something special" but overall did not enjoy it that much. Being on the road was a lonely time, and he thought the people at the club were "tough." He recalls, "I probably would have liked the job a lot more if I learned not to gamble until I went broke."

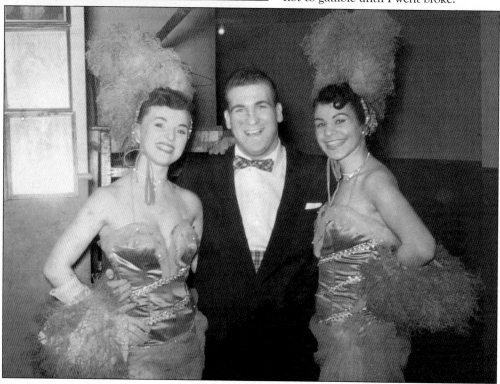

Opera singer Marguerite Piazza had a storied career. She went from the New York City Opera in 1944 to Broadway in 1950 then to television. In 1951, she played Rosalinda in *Die Fledermaus* in the Metropolitan Opera. She joined the cast of NBC's *Your Show of Shows* alongside Sid Caesar and Imogene Coca in 1950. After 1954, she went on a nightclub tour and sang opera at Beverly Hills where, on this evening, Clark found her standing by the wings.

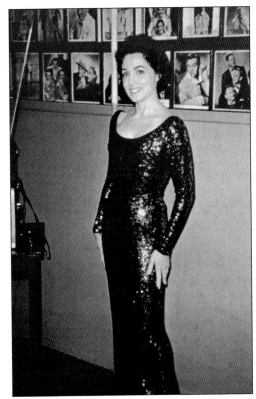

One of the few venues that still shows tap dancing includes talent shows on television. Steve and Jimmy of the legendary Clark Brothers pose near the stage door on either side of Beverly Hills' master of ceremonies Dick Hyde. This tap-dancing duo started at Harlem's Cotton Club in 1940 and played a circuit of 200 black vaudeville theaters. They danced across the country in lounges, nightclubs, and theaters through the 1940s until they went on to further success in England.

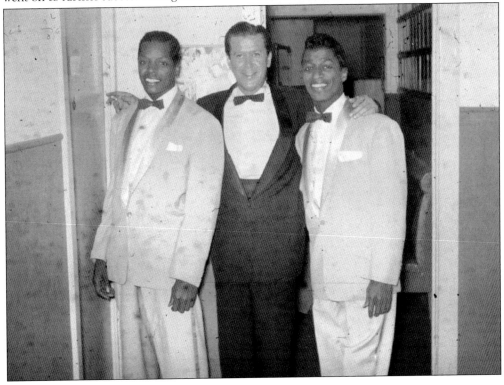

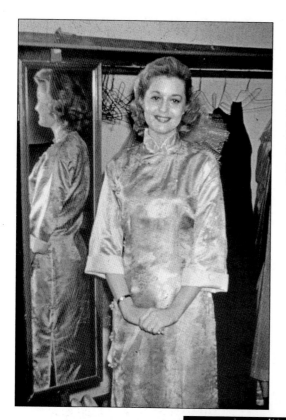

At age 11, Constance "Connie" Towers turned down an offer from Paramount Pictures in order to sing opera. After starring in a summer stock production of *Carousel*, she decided to pursue a career in musical theater. She sang at Beverly Hills fairly early in her career, when her first movie came out, and poses for Clark in her dressing room. She would go on to have a lifelong career starring on the stage, screen, and television.

An interesting aspect about Beverly Hills was how often the entertainment changed. For two weeks audiences would see a New Orleans–themed presentation. The next presentation was a summer show from the South Seas, as production singer Dean Campbell demonstrates in August 1954. Clark snapped this night photograph just outside the stage door.

Throughout entertainment history, there has been only one Milton Berle. "Mister Television's" first role was in a 1914 silent film, and by 1929, he was already appearing on experimental television as well as on the vaudeville stage. He performed stand-up comedy in the 1930s while starring on radio through the 1940s. When he moved from radio to television in 1948, he was so popular that businesses closed while his show was on. Because of him, sales of television sets skyrocketed. After "Uncle Miltie's" television show was cancelled in 1956, he headlined at Las Vegas casinos and Beverly Hills, captured here enjoying the company of two showgirls. He probably also spent some time in the casino. His eight-decade career had no end in sight. He did nightclub tours, Broadway, films, television, and even dabbled in songwriting. His highly visual, sometimes outrageous, vaudeville style appealed to every generation that watched him. Even though Berle had a colorful vocabulary, he always kept his act clean.

Billed as the "Park Avenue Hillbilly," Dorothy Shay dressed like an elegant society woman and sang country-comedy tunes. She toured with the USO during World War II and recorded a number of singles, including her 1947 hit, "Feudin' and Fightin.'" Shay was a smash on radio, stage, and television, and appeared at Beverly Hills in the early 1950s. Wearing a red strapless gown, she poses in front of a trampoline used in an acrobatic act. Even today some of her music can be heard on the *Dr. Demento Show*.

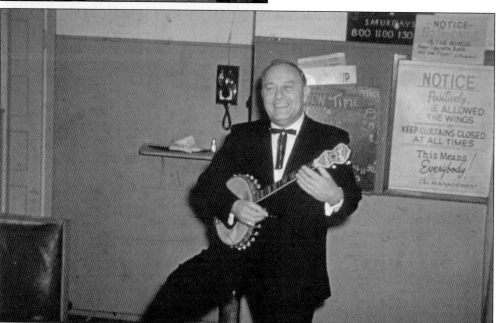

Whenever Harry "Woo-Woo" Stevens came to an off-color word during his banjo comedy act the audience yelled "Woo-Woo!" He is rehearsing backstage near the wings with stern reminder signs posted behind him. Regrettably, audience-participation nightclub routines like Stevens's homespun comedy act have vanished from the modern stage.

In 1933, "Little Georgie Gobel" was only 13 years old when he was singing on *National Barn Dance* on WLS radio. By his late teens, he was playing county fairs and making records. While serving as a pilot instructor during World War II, he developed a stand-up comedy act. After the war, the self-renamed George Gobel took his act to nightclubs nationwide. Here Gobel shows his diminutive size outside his dressing room. By this time he was on television, starring in the *George Gobel Show* from 1954 to 1960.

The backstage television set was turned off when actress and singer Roberta Sherwood arrived with her son. Years earlier she had retired from a young life on the vaudeville stage. After her husband, Don Lanning, died in 1956, she went back to a regular singing engagement in Miami. With her newfound success, she went on television and toured nightclubs from New York's Copa Cabana club to Hollywood and Las Vegas. She recorded a string of hit singles, including "Up a Lazy River" and "You're Nobody 'Til Somebody Loves You."

Dancer and choreographer George Tapps broke new ground when he combined ballet with tap in a performance of Ravel's *Bolero*. He made his Broadway debut in 1927 in the musical-comedy *Judy* and replaced Gene Kelly in *Pal Joey* in 1941, his fifth Broadway show. In the 1950s, he went on the *Jackie Gleason* and *Red Skelton Shows*. His nightclub tour brought him to Beverly Hills, where Tapps (pictured at left, center) poses with his dance troupe, two of whom wear suggestive peach outfits.

Seen earlier in rehearsal at the piano, insult comic Jack E. Leonard poses in his trademark dark suit beside the staff's Christmas tree backstage, fondling one of the ornaments playfully. Whenever Leonard performed at a casino, he enjoyed ripping on the losers and high rollers, who appreciated his humorous asides. Beverly Hills' casino was not immune to Leonard's wit.

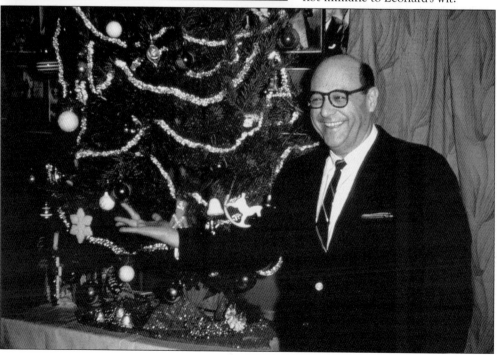

In the 1950s, singer Gogi Grant was an active television performer and recording artist but had yet to achieve stardom. She headlined at Beverly Hills when she released "Suddenly There's a Valley." Her follow-up, "The Wayward Wind," went to No. 1. Seated on a stool, she poses backstage, dressed in a strapless evening gown. She would continue to make television appearances and more records, but when her popularity declined, she retired from recording in 1967. She continues to perform in her 80s.

After being crowned Miss New York 1939 and appearing in a Broadway show, Marie McDonald dreamed of working in show business. She moved from Yonkers to Los Angeles, became a nightclub showgirl, and sang on Tommy Dorsey's radio show. Finally making the silver screen, she was nicknamed "the Body." A famous World War II pinup girl, she later made the tabloids for her many scandals and seven marriages. She went on television and made records; her 1957 nightclub tour brought her to Beverly Hills. She died from an overdose in 1965.

It is a shame that so many performers who entertained at Beverly Hills have long since been forgotten. This supporting-act musical trio, consisting of a female singer and two handsome male dancers, are victims to the pages of time. The only hint of who they might have been is written on the chalkboard as "Jean and." Whoever they were, they appeared on the same bill as headliner Dorothy Sarnoff.

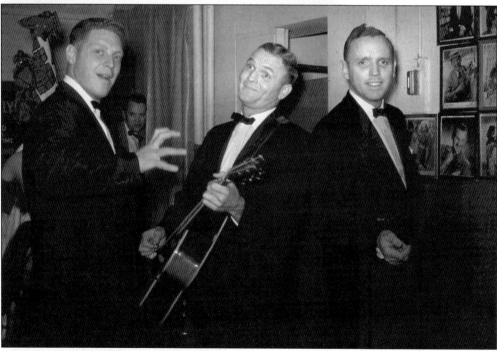

The gimmick of this musical trio, Somethin' Smith and the Redheads, was that all three members had red hair. Never achieving any lasting fame, they performed 1950s pop standards at supper clubs, hotel lounges, and, of course, Beverly Hills. They recorded a few singles; their biggest hit, "It's a Sin To Tell a Lie," made it to No. 7 in 1955. Pictured from left to right are Saul Striks on piano, Somethin' Smith on vocals and guitar, and Major Short on bass. A showgirl with a tall headpiece stands behind Striks.

Dance teams from all corners of the globe performed in one of the opening numbers. Some groups were established favorites, while some were struggling to make it. Many trios included a male singer and two gorgeous female dancers. Their talent is remembered, but as it happens, their names have been lost.

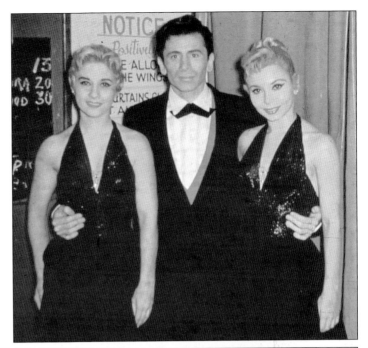

Probably better known to the 1950s nightclub crowds was Rowena Rollins (left), standing with her husband, Bob Williams. Rollins toured the clubs performing a "guzzler's gin act," a classic vaudeville routine in which she continually added wine to glasses set out for a formal dinner. Throughout the routine, she kept sampling each glass until she was drunk. Her husband, Bob, had a trained dog act in which the dogs would perform limp or energetic as the situation required.

Actor and singer Gordon MacRae got his start in a Broadway play one month before the onset of World War II. After his first movie *The Big Punch* debuted in 1948, he started appearing in films opposite Doris Day. His hit records included a duet with Jo Stafford, "My Darling, My Darling." He starred on television and appeared in musical films, including *Tea For Two*, *Oklahoma!*, and *Carousel*. On his nightclub tour at Beverly Hills, he and his wife, actress Sheila MacRae, pose in front of their dressing room.

A quartet from Buffalo, New York, called the Modernaires joined Fred Waring's orchestra around 1936. They made a string of recordings before defecting to the Glenn Miller Orchestra in 1940. After recording "It's Make Believe Ballroom Time," they added singer Paula Kelly and made musical history. With Glenn Miller, the quintet went on tour and cut countless hit records. When Miller went missing in 1944, the Modernaires continued touring and recording, headlining at Beverly Hills in the late 1950s.

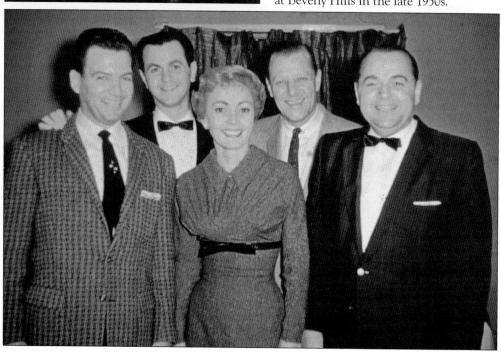

When Jane Morgan studied opera at Julliard and performed in a nightclub, Art Mooney hired her to sing in his orchestra. She soon moved to Paris and made records while performing in French nightclubs and across Europe. She later returned to New York and sang at the St. Regis Hotel while appearing on television and making records. Her 1957 recording of "Fascination" was a million-seller. She poses here in a red and black gown at Beverly Hills. She would later star in Broadway's *Mame* in 1969.

A male quartet that has largely been forgotten today is the Kirby Stone Four. Formed after World War II as an instrumental group, vocals took dominance when playing New York clubs. Audiences loved their style of melding swing-jazz, vocalese, rock-and-roll, and humor. They made records with Columbia after appearing on the *Ed Sullivan Show* in 1957. The resulting Grammy-nominated single, "Baubles, Bangles, and Beads," went to No. 25. By the mid-1960s, the harmonizing quartet was declining in popularity and the Kirby Stone Four turned to rock.

Local talent often graced the stage at Beverly Hills. Cincinnati's Jeri Adams previously sang with Gardner Benedict's orchestra. She had toured nationwide nightclubs until star Frankie Laine discovered her. She was a featured singer at major clubs and sang steadily with the Cincinnati-based Teddy Raymore Trio. When she appeared as a supporting act at Beverly Hills, she dressed elegantly in a black evening gown and long white gloves.

Seen earlier in rehearsal, Broadway actress and singer Lisa Kirk stands in her dressing room, ready to go on stage. Recently she had played the role of Lois Lane in *Kiss Me Kate*, which had closed in 1951 after running three years at the Shubert Theater in New York City. She was seen on a number of 1950s television programs, including *Colgate Comedy Hour* and *General Electric Theater*, and later the *Ed Sullivan Show*.

Some music fans believed that Vic Damone (left) possessed a voice better than Frank Sinatra's. Before making it big, Damone took first place on *Arthur Godfrey's Talent Scouts* radio program in 1947. By the next year, he was playing Los Angeles nightclubs and had his first No. 7 hit, "I Have But One Heart." He was a recording star and movie actor when he joined the army in 1951. After his 1953 discharge, he made movies, records, and television appearances. Here he poses beside saxophonist and conductor Dick Stabile.

Wrapped in a white fur over a silver evening gown, singer Marilyn Marlowe exits the stage door after her show. She is planning to head back to her hotel to freshen up, then hit Cincinnati for a night on the town. Marlowe appeared in only one film, the 1937 comedy *Postal Union,* and toured the country singing at nightclubs in the 1950s.

Conrad Buckner, aka "Little Buck," performed a skillful tap dance and comedy act in 1950s nightclubs and was on television through the 1960s. He looks relaxed as he waits backstage for his cue. This photograph shows that the emergency exit on the right appears to be padlocked. Decades later, during the 1977 fire investigation, it was revealed that some of the exit doors may have been locked, possibly preventing many from escaping.

Immediately after their show, the Ritz Brothers have thrown their tuxedo jackets over their white robes for this photograph. As vaudeville headliners in the 1930s, they made a number of films, with their first being the 1934 short *Hotel Anchovy*. On stage they emphasized precise dancing, breaking into song at a moment's notice and adding comedy routines as they went along. They made more movies through the 1940s and appeared on television and in nightclubs through the 1950s. Pictured from left to right are Jimmy, Harry, and Al.

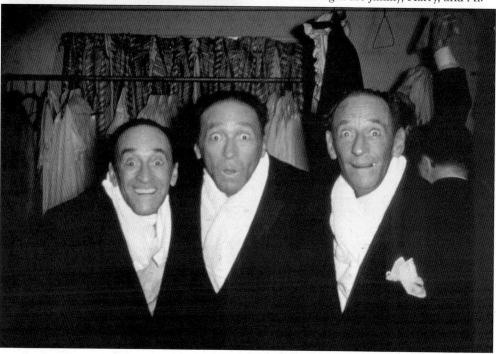

Fresh from her three-year role as Brenda in Broadway's *The Pajama Game*, actress and singer Marion Colby came to Beverly Hills in 1956 to sing in one of the opening numbers. *Pajama* was the last Broadway production Colby appeared in. She never achieved the success of some of her contemporaries but would appear in a few films and early television. She died in 1987.

Occasionally Beverly Hills would bring in a Broadway production and present it in its entirety in one evening. Such was the case of Michael Todd's *Peep Show*, which ran at New York's Winter Garden Theater from 1950 to 1951. One of the cast members poses for Clark backstage in front of the emergency exit. *Peep Show* was unique at the time for being one of the first musicals to experiment with nudity on stage.

"The Big Mouth," actress and singer Martha Raye was born in 1916 to the married vaudevillian team Reed and Hooper. She performed during the next two decades with little formal schooling, becoming a band vocalist in the early 1930s. She attracted a following with her outrageous pratfalls in the chorus line at Chicago's Chez Paree. After heading to Hollywood, her first film appearance was in the 1934 short *A Nite in the Nite Club*. Two years later, she signed with Paramount and starred in *Rhythm on the Range* with Bing Crosby. During the next 26 years, she appeared in films with all of the comedy legends: Bob Hope, W. C. Fields, Charlie Chaplin, Jimmy Durante, and many others. She toured with the USO during World War II, the Korean War, and Vietnam, and her show, the *Martha Raye Show,* aired from 1954 to 1956. From the 1950s through the 1980s she was all over the television and is well remembered for her 1980s Polident commercials. When she appeared at Beverly Hills in the late 1950s, she smiled big for Clark's camera.

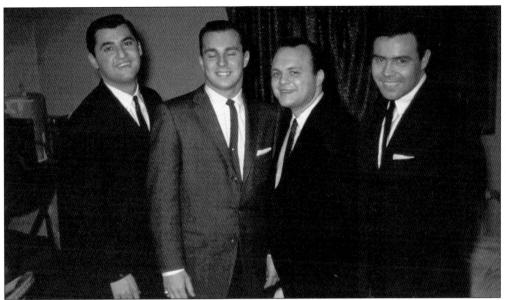

The biggest and only hit by the Canadian quartet the Rover Boys was "Graduation Day" in 1956 and would be covered by the Four Freshman a year later. The Rover Boys released a number of other singles, but modern radio seems to have forgotten them while recognizing other 1950s quartets like the Lettermen and the Four Freshmen. Similar to most other musical groups on the rise, they took their show on the road to Beverly Hills, posing here in their dressing room.

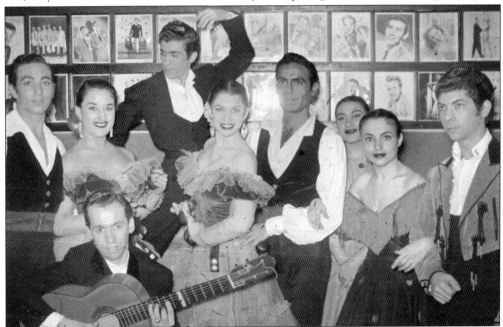

After a six-year European tour, the Jose Greco Company of Dancers returned to the United States in 1952 to perform in a Broadway production starring lead man Jose Greco. For the next 20 years, the Greco Company took more than 40 U.S. and 6 world tours, including an engagement at Beverly Hills. Greco was a regular guest on 1950s television programs and appeared in *Around the World in 80 Days*. The whole company poses backstage with Greco at center beside his partner, Pilar Lopez.

News commentator Walter Winchell called her the "Incomparable Hildegarde." She made the cover of *Life* magazine in 1939. The cosmetics company Revlon named a shade of lipstick for her. Known simply as Hildegarde, this blonde, hazel-eyed beauty, who lived to age 99, grew up in Wisconsin. When the vaudeville stage beckoned her, she became the most popular cabaret singer that ever lived. She entertained the troops in both World War I and World War II, and was the first entertainer to go by a single name. Her records sold in the hundreds of thousands, and nightclubs across the country begged her to play at their venue. On stage her elegance was unmeasured. She wore long, white gloves and an evening gown while singing and playing the piano. This most famous supper club act in history performed at Beverly Hills in the late 1950s. The Incomparable Hildegarde (center) poses backstage with her conductor (left) and singer Johnny Johnston.

Nine

ON STAGE AT BEVERLY HILLS

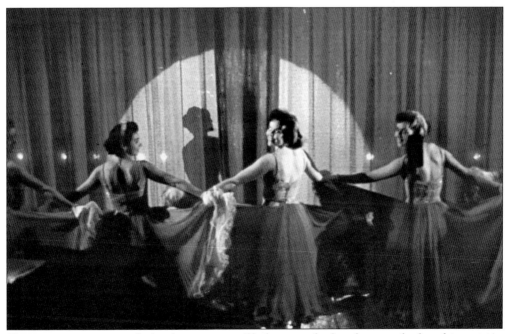

Showing a unique, one-of-a-kind perspective, Clark snapped a few photographs from his position in the orchestra on stage. Here the dancers turn to smile for the camera just before the curtain slides open. In front of the audience, the spotlight shines on 18-year-old Mary Fassett, a local singer from Hamilton, Ohio, seen on page 37. This talented young woman is providing the vocals for the opening production number.

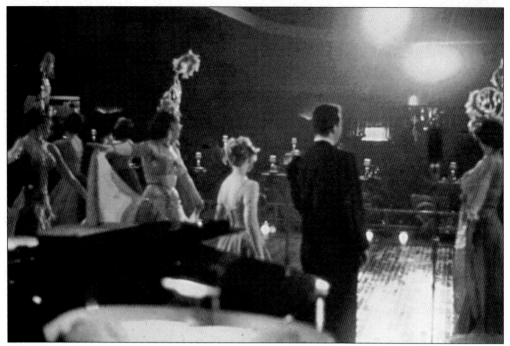

The dancers have taken the stage and have come to the midpoint of their show. Petite Mary Fassett stands beside production singer Clay Mundy while the dancers move about the stage in their choreographed routine.

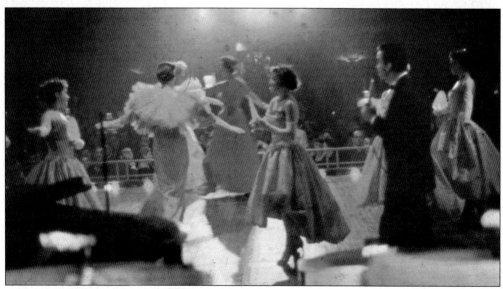

On another evening, the dancers in the show frolic around the stage and thrill the audience as another spectacle at Beverly Hills begins. While this is going on, Clay Mundy (right) sings the production number that leads into the opening act.

Dieter Tasso mixed juggling and balancing with comedy. He would open his show by making the audience laugh at feigned incompetent juggling. He next tossed cups and saucers in the air and caught them on his head until he had a stack. He finished by walking across a slack wire with cups and saucers balanced high on his head. This Berlin, Germany–native performed in the Ringling Brothers circus and had appeared on television before he came to Beverly Hills. Later his act was seen at the Lido in Paris and elsewhere internationally.

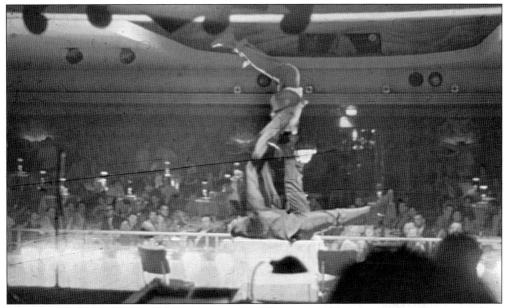

Balancing acts like the European team Janus and Bagio probably started practicing as children. Once they had developed their skills, they would have joined a circus and performed next to the caged animals and clown acts. As time went on, Janus and Bagio would have appeared in variety shows and eventually in nightclubs, which featured the many similar acts that appeared on stage at Beverly Hills.

One of the top three jugglers in the world who performed at Beverly Hills was Francis Brunn. Here he demonstrates a celebrated routine involving juggling balls and spinning them on his finger. A stage hand would toss him more balls or rings. Essential to this sort of show, the orchestra provided drum rolls and cymbal crashes. He may have done this same act when he later performed for Pres. Dwight D. Eisenhower at the White House. The smoky haze over the audience is especially evident this evening.

Billed as the "Last of the Red Hot Mamas," Sophie Tucker was in her 70s when she played Beverly Hills. She started performing in 1903 at age 19 and appeared in the Ziegfeld Follies in 1909. For her entire life, she was an entertainer. She performed in vaudeville and burlesque, made records, and was in movies and on television. Here she reminisces on stage about her earlier days, also reminding the audience that copies of her autobiography are for sale in the lobby.

Three-time Tony Award winner and Oscar nominee Carol Channing is on stage eating up the laughter and appreciation from the audience. She was best known for her recent role in Broadway's *Gentlemen Prefer Blondes* and in the musical *Wonderful Town*. She had been seen on a number of television programs before playing Beverly Hills. Channing would become famous for her role in *Hello Dolly* in 1964 and continued appearing on the stage, screen, and television for the rest of her life.

INDEX

Adams, Jeri, 114
Allen, Marty, 94
Ameche, Lois, 60
Andrews Sisters, 42
Bailey, Pearl, 62, 85
Barrett, Kitty, 68
Barry Sisters, 64
Barton, Eileen, 101
Baylos, Gene, 87
Beach Combers, 78
Belmont, John and June, 73
Bellson, Louis, 85
Benedict, Dick, 9
Benedict, Gardner, 8, 9, 10, 13, 15, 21, 33, 42, 43, 49, 53, 55, 56, 60, 62, 80, 85
Bennett, Tony, 65
Berle, Milton, 105
Billy Williams Quartet, 16, 76
Blue, Ben, 52, 96
Bob Devoye Trio, 30
Boswell, Connee, 97
Bowsher, Frank, 9, 92
Brunn, Francis, 34, 124
Bryant, Anita, 49
Bryant, Joyce, 50
Burton, Jimmy, 60
Campbell, Dean, 104
Cardenas, Rudy, 35
Carr, Cathy, 99
Cavallaro, Carmen, 99
Channing, Carol, 57, 125
Charles, Victor, 39
Charlivels, 29
Chipburn, Tony, 12
Christy, June, 94
Clark Brothers, 103
Clark, Earl W., 8, 9, 10, 11, 16, 48, 57
Colby, Marion, 117

Cole, Rocky, 92
Contino, Dick, 81
Cornell, Don, 79
Cugat, Xavier, 75
Damone, Vic, 115
Dancing Szonys, 101
Dandridge, Dorothy, 59, 68
Daniels, Billy, 80
Davis and Reese, 66
DeCastro Sisters, 67
DeHaven, Gloria, 88
DeJager, Pierson, 8
De la Rosa, Orlando, 67
Della Chiesa, Vivian, 51
Del Rubio Triplets, 53
Dennis, Beverlee, 54
Donn Arden Dancers, 17
Dorothy Dorben Dancers, 18, 19
Drake, Dick, 43
Draper, Rusty, 90
Durante, Jimmy, 13, 100
Eddy, Nelson, 61
Elsa and Waldo, 36
Fassett, Mary, 25, 121–122
Fields, Sid, 96
Fields and Seeley, 43
Fontaine, Frank, 84
Ford and Reynolds, 34
Four Step Brothers, 76
Froman, Jane, 72
Gardner Benedict Orchestra, 8, 9, 10, 13, 52,
Garrett, Diane, 80
Garrett, Dick, 8, 13, 14, 19
Gibbs, Georgia, 70
Gilbert, Paul, 91, 96
Gobel, George, 107
Goofers, 52
Gorman, Frank, 13, 49, 51
Gorme, Eydie, 83

Grant, Gogi, 109
Grasham, Carl, 8, 12
Greco, Jose, 119
Green, Larry, 61
Greene, Shecky, 51, 102
Hackett, Buddy, 55, 98
Hahn, Wally, 8, 9, 11, 14, 73
Haller and Hayden, 35
Harmonica Rascals, 46
Hawkins, Dolores, 55
Hayes, Bill, 23
Hildegarde, 120
Hyde, Dick, 67, 80, 103
Jacob, Andy, 8, 9, 10, 11, 12, 13, 49, 56, 80, 100
Janus and Bagio, 123
Jimmy Wilbur Trio, 8, 13, 14, 15
Kay, Beatrice, 54
Kaye, Johnny, 72
Kean Sisters, 73, 92
King, Alan, 65
Kirby Stone Four, 113
Kirk, Lisa, 46, 114
Kleine, Bill, 8, 14, 15
La Moret, 38
Lane, Abbe, 75
Langenbrunner, Jim, 8, 48,
Lawrence, Steve, 83
Leonard, Jack E., 56, 71, 108
LeRoy, Hal, 86
Lessee, Ben, 61
Lester, Buddy, 56
Levenson, Sam, 91
Lewis, Jerry, 72
Lewis, Joe E., 87
Liberace, 41, 64, 99
Lindsay Dancers, 23
Lindsay Lovelies, 52
Little Buck, 116
Logan, Ella, 66

Lowe, Charles, 57
Lucky Girls, 27
Madigan, Betty, 97
Marco, Harold, 8, 10
Marks, Guy, 71
Marlowe, Marilyn, 115
Martin Brothers, 38
Mathues, Art Craig, 63
Mavity, Bill, 8, 9, 11, 16, 48
MacRae, Gordon, 112
McCrea, Patricia, 27
McDonald, Marie, 109
McFadden, Bob, 81
McSpadden, Bob, 15
Medert, Charlie, 8, 91
Melchior, Lauritz, 58, 59
Melton, James, 47
Miller, Al, 8, 9, 12, 13
Mills Brothers, 82
Miranda, Carmen, 14
Modernaires, 112
Moore, Patti, 61
Morgan, Jane, 113
Mr. Ballentine, 40
Mueller, Fritz, 8, 9, 10, 11, 13, 20, 49, 92
Mundy, Clay, 95, 122
Musical Wades, 44-45
Navelli, Joe, 32
Nelson, Jimmy, 39
Nichols, Frank, 52
Paxson, Ted, 61
Peabody, Eddie, 37
Peep Show, 117
Piazza, Marguerite, 103
Peligrino, Al, 8, 48
Powers, Marlene, 25, 26, 90, 95
Professor Backwards, 36
Puleo, Johnny, 46
Quinn, Carmel, 42, 49, 88

Raeburn, Boyd, 55
Ramses, 40
Rank, Bill, 8, 11, 13, 32, 49, 52, 85, 90
Ray, Johnny, 75
Raye, Martha, 118
Reyes, Raul and Eva, 92
Rice, Don, 68
Ritz Brothers, 116
Rollins, Rowena, 111
Rose Marie, 89
Ross, Buddy, 51
Rover Boys, 119
Rusin, Jack, 57
Ruskin, Bud, 8, 9, 12, 16, 47, 48, 67
Sargent, Bobby, 98
Sarnoff, Dorothy, 102
Schmidt, Peter, 7
Seaman, Glenn "Hap", 8, 9, 11, 48, 49, 57
Seeley, Blossom, 43
Shank, Hank, 59
Shawn, Dick, 60
Shay, Dorothy, 106
Sherwood, Gale, 61
Sherwood, Roberta, 107
Shook, Wilbur "Shooky", 8, 12, 49
Simpkins, Arthur, 77
Sinatra, Frank, 8, 115
Smith, Ethel, 84
Somethin' Smith and the Redheads, 110
Steele, Jon and Sondra, 74
Stevens, Harry Woo Woo, 106
Svening, Dorie, 28
Tapps, George, 108
Tasso, Dieter, 123
Thomas, George, 8, 11,

Tillman, Ted, 8, 9, 11, 47, 85,
Tippy and Cobina, 33, 71
Torme, Mel, 48
Towers, Constance, cover, 104
Traubel, Helen, 59
Tucker, Sophie, 125
Vagabonds, 93
Van, Bobby, 80
Vincent, Larry, 15
Vincent, Romo, 62
Visionaires, 77
Warren, Fran, 69
Weitzel, Marty, 8, 49,
Westrich, Dick, 8, 11, 12, 13, 49, 80
Wheeler, Bob, 8, 13
White, Paul, 30
Wilbur, Jimmy, 8, 13, 14, 19
Wolfe, Sammy, 96
Wood, Mitch De, 94
Zabach, Florian, 86

www.arcadiapublishing.com

Discover books about the town where you grew up, the cities where your friends and families live, the town where your parents met, or even that retirement spot you've been dreaming about. Our Web site provides history lovers with exclusive deals, advanced notification about new titles, e-mail alerts of author events, and much more.

Arcadia Publishing, the leading local history publisher in the United States, is committed to making history accessible and meaningful through publishing books that celebrate and preserve the heritage of America's people and places. Consistent with our mission to preserve history on a local level, this book was printed in South Carolina on American-made paper and manufactured entirely in the United States.

This book carries the accredited Forest Stewardship Council (FSC) label and is printed on 100 percent FSC-certified paper. Products carrying the FSC label are independently certified to assure consumers that they come from forests that are managed to meet the social, economic, and ecological needs of present and future generations.

FSC
Mixed Sources
Product group from well-managed forests and other controlled sources

Cert no. SW-COC-001530
www.fsc.org
© 1996 Forest Stewardship Council

Find Your Place in History.